OUTDOOR AND SURVIVAL SKILLS FOR
NATURE PHOTOGRAPHERS

RALPH LAPLANT and AMY SHARPE

AMHERST MEDIA, INC. ■ BUFFALO, NY

Published by:
Amherst Media, Inc.
P.O. Box 586
Buffalo, N.Y. 14226
Fax: 716-874-4508
www.AmherstMediaInc.com

Publisher: Craig Alesse
Senior Editor/Project Manager: Michelle Perkins
Assistant Editor: Matthew A. Kreib
Scanning Technician: John Gryta

ISBN: 1-58428-017-4
Library of Congress Card Catalog Number: 99-76256

Printed in the United States of America.
10 9 8 7 6 5 4 3 2 1

This book is dedicated to its readers who not only appreciate nature's beauty, but by capturing it on film, share that beauty with others.

Table of Contents

Introduction

Nature photography can be very rewarding, but those rewards must be earned. Purchasing photography equipment and learning how to use it are only the first steps. The successful nature photographer must be able to choose the types of equipment that can help him or her be more successful during the shoot and must know how to protect that equipment. The nature photographer must have an insight into finding and approaching the photographic subject, while treating the environment with due respect. Finally, in order to remain safe and comfortable during an outdoor shoot, the nature photographer must have a basic knowledge of outdoor skills. As a growing number of people show an interest and actively participate in nature photography, there is an equally-growing need for resources that outline skills essential to this medium.

Night and day differences exist between studio photography and nature photography. Indeed, both require a camera, proper lighting, exposure, composition and the like, but the nature photographer is "exposed" to subjects that sometimes, at best, cooperate like a two-year-old child having his portrait taken.

At worst, the nature photographer finds himself out-of-doors when environmental extremes present themselves. This book will provide insight into meeting the challenges that the nature photographer may face, instruction in the basic skills that will help ensure a successful, safe and enjoyable photo session, and will provide the photographer with incentives to continue to learn about the subjects introduced.

> "To remain safe and comfortable, the nature photographer must have a basic knowledge of outdoor skills."

While writing this book, every attempt has been made to provide state-of-the-art knowledge and advice in a rapidly-advancing field of technology. The reader is invited to use this material as the starting point for a life-long exploration into the pleasures of nature photography.

CHAPTER 1
Equipment

Today's technology gives the nature photographer opportunities to choose among many different cameras, lenses and accessories, but because of its many advantages, many nature photographers choose 35mm format for their work. A 35mm system is ideal for nature photography because it is light and maneuverable, unlike medium and large formats. With fast lenses (those with large apertures) and film, many images can be captured while hand holding equipment. 35mm film and its processing is widely available.

Many of today's nature photographers opt for autofocus (AF) camera systems. In most situations, these camera bodies and lenses give precise and rapid focus of subjects. This allows the photographer to concentrate on other factors such as composition and exposure.

> ## "Most of the needs of the nature photographer can be met with these two lenses..."

Lenses used in nature photography vary in length, maximum opening (f-stop) and focal length (power). In 35mm format, a 55mm lens is about one power; lenses greater in length are telephoto, and those with a shorter focal length are wide angle. Lenses that "zoom" give adjustable focal lengths. Two popular zoom lenses are the 28-75mm and 75-300mm. Most of the needs of the nature photographer can be met with these two lenses, or one that covers this focal length range.

Some photographers prefer medium and large format camera systems. These are often used by those who concentrate on landscapes and wildflowers where the subject is stationary. The larger negative size produced by medium and large format systems can yield clearer images.

TRIPODS AND OTHER SUPPORTS

☐ **Tripods.** In photography, especially nature photography, the photographer needs to be able to minimize camera movement as much as possible. A studio photographer usually deals with one moving element – the subject. A nature photographer working outdoors often deals not only with a moving subject, but also with the effects of wind on normally-steady subjects such as vegetation. Wind can

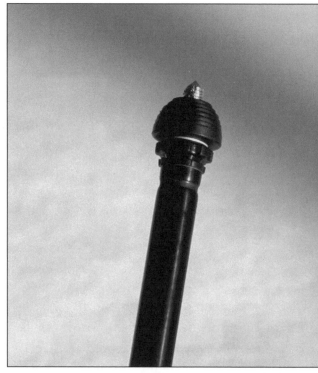

Left: A heavy item, such as a camera bag, secured to and suspended from the tripod, will provide weight needed to stabilize the camera and lens.

Above: Spiked legs will help prevent the tripod from moving on ice or smooth terrain.

also affect camera and lens movement. A moving lens not only magnifies the image, but exaggerates the photographer's movement as well. The result is a blurred image on the film.

The indoor photographer more often than not has adequate light or can utilize a flash to compensate for low light. Most nature photography is done without the advantage of bright light. Often, nature photographers avoid the harsh light of mid-day, preferring to work in the morning, evening, or even during the middle of the night when animal movement is more frequent. These low light conditions require low shutter speeds for proper exposure, further necessitating steady camera supports.

Cameras and lenses can be supported by a number of methods and devices. Anything that does the job, does the job. The best rule, simply put, is that if you can use a tripod, use a tripod. There are many brands and models of three-legged supports available in various heights, weights and with various options; choosing the right tripod to suit the individual photographer's needs requires some thought. The general rule to follow is that the heaviest tripod that can be carried will usually give the best support, since weight tends to add stability. The problem here is that the added weight of a heavy tripod might not be worth the effort required to carry it. An 11- to 14-pound tripod is usually advisable since this is heavy enough for stability, yet light enough to be carried about. Usually a tripod heavy enough to hold the camera body and the heaviest lens steady is heavy enough.

Tripods may be constructed from wood, plastic, metal or composites and should have several basic features. First, consider the tripod legs. They may have open square or rectangular channels that can allow dirt or vegetation to enter. Look for strong legs that do not allow foreign matter to accumulate. Adjustable legs not only help raise and lower the camera, but can be adjusted separately to accommodate uneven terrain. Spiked feet keep the tripod and what it is supporting from slipping, a nice feature when the photographer is working on ice.

> "Look for strong legs that do not allow foreign matter to accumulate."

Some tripods feature an adjustable center pole allowing the camera to be raised and lowered more quickly. Thumb clamp locking handles provide a secure mount and are easy to use even with gloved hands. Padded legs not only keep the photographer's hand from becoming cold in chilly conditions, but provide cushion when the tripod is carried over the shoulders. These pads can be purchased from a camera equipment supplier or fabricated by using pipe insulation (available at hardware stores).

When the tripod is carried over the shoulder, a carrying strap frees the photographer's hands.

The mechanism that connects the camera body and/or lens to the tripod is the head. There are different types of heads available and, as with the tripod, the head needs to be strong enough to hold the equipment. Some tripod heads have mounts that facilitate the

Whether store-bought or made from pipe insulation, soft pads wrapped around a tripod's legs will give the photographer's shoulder a break from the weight and cold.

Small and easy to carry, the mini tripod will stabilize lighter weights. To add height, the mini tripod can be placed on a surface above the ground.

Above: Some lenses cost a fortune. It is cheap insurance for the photographer to place his arm through the lens strap just in case it slips out of his grasp.

Below: A quality tripod head will securely hold the weight of the camera body and lenses, helping to assure that the image obtained is not blurred. The rail, a device that allows the photographer to bring the camera and lens forward, backward and sideways with precision, helps compose the shot.

quick mount or dismount of the photography equipment. Others simply use a quarter-inch diameter, 20-threads-per-inch bolt that inserts into the camera or lens and is tightened. Some heads feature a ball-type pivot which allows quick rotation of the photography equipment. Others tilt downward, upward, left and right by loosening levers and knobs.

Tripods are available in several colors. In the field, black or green finishes blend into the surrounding area more readily than shiny metal, which may reflect light and spook the nature photographer's subjects.

Tripods vary in price range, and you do tend to get what you pay for. Ball heads give fast, almost unlimited, rotation of the camera and lens, but are expensive. Tilt pan heads are more affordable and do the same job as ball heads, but are a little slower to adjust.

☐ **Window Mounts.** Photographing from a vehicle is a common practice for the nature photographer. An easy way to support a camera and lens while shooting from a car or truck is to use a window mount, simply a clamp with a head attached to the top which allows the camera to be angled up and down, left and right. Adjust the window height to raise or lower the camera and mount.

> "Photographing from a vehicle is a common practice for the nature photographer."

☐ **Monopod.** For quick movement of gear and relative stability, the nature photographer can use a monopod. This one-legged device is often used by photographers at sporting events. It is light and gives the photographer the ability to move around quickly. Because a monopod has only one leg, there is a limited chance of tripping over it. The monopod can

Secured to a vehicle's window, the window mount acts like a tripod. The camera body and lens can be moved in most directions, either by moving the mount's head or by moving the window up or down.

be tilted and rotated to accommodate most photographing angles. Heads that are designed specifically for monopods provide more controlled up and down tilt.

☐ **Brace.** A brace that resembles a rifle stock is a very effective support when panning moving subjects such as birds. With a camera and lens mounted on the brace, the photographer can use either a mechanical or electrical shutter release, remembering to continue panning with a follow through after the shutter is released.

Left: A monopod can be stabilized by bracing the bottom of the leg against the inside of the foot, against the knee and by gently pushing downward on the top of the camera or lens.

Below: This moose was photographed with the aid of a rifle stock. The telephoto lens and camera body was heavy, but the stock gave ample support to take the shot.

Camera gear supported on a rifle stock-type support can be moved with ease and is especially useful when panning moving subjects. The photographer, like the trap shooter aiming at clay pigeons with a shotgun, should remember to follow through the movement.

☐ **Sandbags.** Sandbags are just that—bags filled with sand. A sandbag is desirable when the photographer wishes to rest the camera body on an irregular surface such as a log, rock or the ground, or on a firm, but slippery surface such as the hood of a car. The sandbag conforms to the shape of the camera as well as to the surface it is resting upon.

The photographer can adjust the camera until it nestles in for a fit. Sandbags are nice to have, but bulky to carry. Sometimes it is possible to fill a bag with sand, dirt or fine gravel on location, making this device more practical. In the absence of a sandbag, other simple, but effective supports can be devised, including placing equipment on a folded piece of clothing.

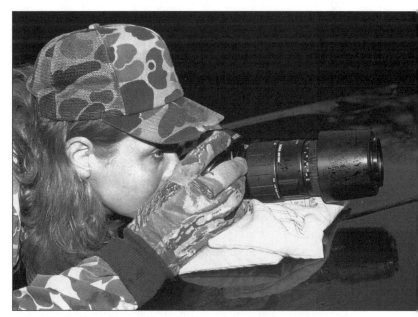

A bag filled with sand provides moldable support. It will not only conform to the camera body and lens, but to what it is resting upon.

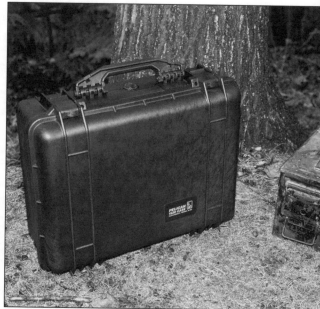

Left: Like the sandbag, folded clothing can provide flexible support for the camera and lens.

Above: Although not bullet-proof, hard cases will take most bumps and bruises and are usually waterproof. With adequate padding inside, they protect camera gear. A "poor man's" hard case can be a steel military surplus ammunition box.

No matter what type of support is used, photographers can learn a trick used by competitive bench-rest rifle shooters. Squeeze the shutter just before you have completely exhaled. Your heart rate is slowest then, and movement – even minute – is movement.

CARRYING BAGS AND VESTS

Carrying and protecting photography equipment is always a concern, especially for the nature photographer who may find himself working outdoors in adverse conditions. Various containers can be used. To some degree, the photographic environment will determine the choice of container.

□ **Hard Cases.** Hard cases are usually made of metal or plastic, are waterproof and when well padded inside, offer great protection from bumps and bruises. Some hard cases are so water and air tight, they are equipped with adjustable vents to equalize the pressure

> "To some degree, the photographic environment will determine the choice of container."

inside and out when changing altitude. These cases are great for shipping equipment, but are less desirable for carrying gear in the field because, unless they are set down, they do not provide easy access to the contents.

□ **Soft Cases.** Soft cases are designed more for field use than are hard cases. While shouldered, the case can easily be opened and equipment removed or replaced. Generally constructed from some sort of fabric, soft cases are usually not waterproof, but some are "water resistant." These cases can withstand rainfall, but will not prevent damage to the contents in case of immersion in water.

☐ **Waterproof Bags.** Waterproof bags are designed for carrying gear when the chances of immersion are great – canoe or kayak expeditions, for instance. Waterproof bags are handy for stowing soft bags and other gear, and while they are not "bullet proof," the bags can withstand some abuse. Waterproof bags come in various sizes and shapes and some, according to manufacturers' labels, are not recommended for camera equipment. This is because the bags do not offer much protection to the contents if the bags are tossed around.

☐ **Vest.** A photographer's vest is a handy accessory. The vests contain pockets that can accommodate most every basic item needed in the field, except possibly the tripod. A little experimentation with placing gear in the vest will help the photographer find it fast in the field. Some vests are made of cloth, others have mesh linings for comfort in warmer temperatures, others are made of leather, providing warmth, durability and style.

"A little experimentation with placing gear in the vest will help the photographer find it fast..."

 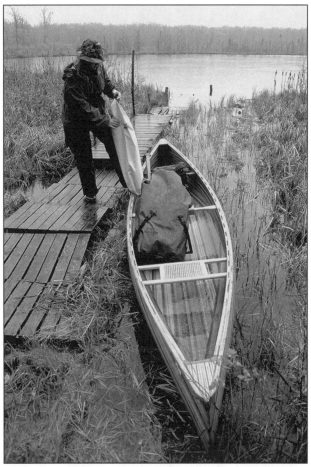

Left: Easily carried on the photographer's back, 80 pounds of gear can be brought to a remote site in a soft case such as the Lowepro Trekker.

Right: If your camera gear is immersed in water, you will probably have to call it quits. But if your gear is in a waterproof bag and tethered to your water craft, the equipment can be retrieved and used. Remember, waterproof bags do not protect the contents from jarring.

Before purchasing a vest it is a good idea to try it on for a proper fit, and fill it with the equipment it is intended to carry. Before purchasing a camera hard case, soft bag or waterproof bag, make sure your gear will fit inside.

Left: A photographer's vest is a convenient way to carry spare lenses, filters, film and other gadgets.

Above: On warm days, it is nice to be able to keep the sun's rays off your head and away from your eyes. A wide-brimmed hat not only does this, but also keeps rain from your face and neck.

CLOTHING FOR ALL SEASONS

No matter what the season, improper clothing can place the nature photographer in harm's way. The appropriate clothing can make seasonal extremes tolerable and protect the photographer from the elements.

☐ **Warm Temperatures.** In warmer temperatures, clothing should provide protection from the sun's rays and allow evaporation of perspiration, thereby keeping the photographer's body cool. The photographer should keep his or her body and head covered during the day and use UV (ultraviolet protection) for exposed skin. Loose-fitting, long-sleeved shirts and long pants provide the best protection. Sunglasses and a hat with a bill or wide brim help prevent eye damage.

The photographer must remember that it may be hot during the day, but cold at night, and be prepared for both extremes. The best solution is to wear layers of clothing which can be removed or added as need be.

☐ **Cold Temperatures.** Obviously, in cold temperatures the goal is to remain warm. Body heat is lost by radiation, convection, evaporation and respiration. The goal here is to prevent heat loss. It has been properly stated, "If your feet get cold, put on a hat." This may seem absurd, but fifty percent of body heat is lost from both the head and neck, due to the large amount of blood circulation close to the body's surface in those areas. In cold weather wearing a hat and neck covering is critical.

Falling in a lake, working in the rain, or perspiring all make the skin wet, and wet skin hastens a decrease in body temperature. Since wet skin removes body heat many times faster than dry skin, it is recommended that clothing worn next to the skin be made from materials to wick perspiration away from the body. Such fabrics include REI's Moisture Transport System®, polypropylene and capiline.

Outer clothing layers should be loose fitting to allow for ventilation of excess body heat when needed, and to create layers of air that act as insulation. Ideally, the outer layer should provide protection from rain or snow, and wind, which greatly removes body heat by convection. Gortex® and Ultrex® are two examples of outer materials that prevent moisture from entering, but allow moisture to leave.

> ## "Proper footwear is an important consideration for comfort and safety."

Proper footwear is an important consideration for comfort and safety. For extreme cold conditions, boots with removable liners are recommended. Since liners become wet from snow, rain and perspiration, they should be removed daily to dry. The outer layer of footwear should be water resistant or waterproof. To ensure that footwear remains waterproof, follow the manufacturer's recommendations for regular maintenance. Be aware, however, that certain waterproofing materials have noticeable odors (mink oil, for example) that will be detected by wildlife.

In cold weather limit exercise to avoid perspiring. Again, layers of clothing can help

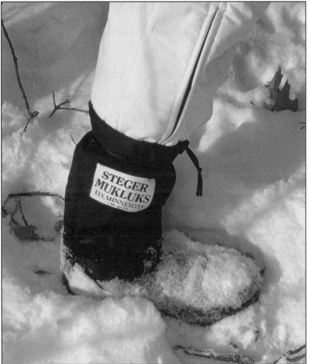

Top: Keeping the head and neck covered is a priority in cold environments. Many types of head wear are camouflaged to match surrounding conditions.

Bottom: No one likes cold feet. Mukluks (here by Steger) have felt liners and insoles, an outer shell that can easily be made water resistant, and when laced properly, prohibit snow from entering from the top. They are comfortable, light and extremely warm.

moderate body temperature. Cold? Add a layer. Warm? Remove a layer.

Stylish clothing has its place, but serious out-of-doors people dress for practicality, which sometimes leaves the swank clothing in the closet at home to be saved for social events.

MISCELLANEOUS GADGETS

Photographers, especially nature photographers, are "gadgetaholics," and years ago camera bags were called "gadget bags." Photographers need certain tools to do the job. Some are essential, and some are luxuries. Trying to distinguish between the two can be time consuming and expensive.

Nature photographers have unique equipment requirements. Not only do they need the tools common to most other photographers, but because they work in temperature extremes, poor lighting (or sometimes at night with no light), in water craft or aircraft, in thick woods or open fields, on snow, ice and in other unique situations, various gadgets become desirable.

□ **Film Storage.** Film does not remain healthy in high temperatures. At home, it is easily stored in plastic bags in the refrigerator. In the field, a white insulated cooler helps keep film cool. The white reflects the sun's rays, and if an ice pack or ice in a plastic bag is placed inside, the film should remain cool for some time. Storing the film in a plastic bag prevents it from becoming wet, should the coolant leak. Transfer the film from the cooler to a camera bag just prior to usage. Be sure to let the temperatures equalize before using the film to prevent condensation on the film.

> ## "In the field, a white insulated foam cooler helps keep film cool."

□ **Flashlight.** When working at night, lighting for making equipment adjustments can be a problem. The obvious solution would be to carry a flashlight, but certain problems can occur using a standard flashlight. If your eyes get a blast from a flashlight in the darkness, you will temporarily lose your vision. This is the result of constriction of the pupils of the eyes, similar to a camera's shutter during exposure to bright light. Avoid this by putting a magenta filter (supplied with some flashlights) over the flashlight lens.

Most of us have two hands, at most. Imagine this: you are setting up your camera and lens (an expensive lens) on a tripod and it

A small cooler with ice or other coolant can prevent film, which is heat-sensitive, from being damaged. Before using the film, remove the plastic storage bag from the cooler, and allow the temperature inside and outside the bag to equalize to prevent condensation.

Top: A cable release "insulates" the photographer from the camera. Even pushing on a shutter release can cause vibration, and vibration will cause a blur in the final image. Use a cable release when possible.

Bottom: To prevent the annoying bounce a camera and lens makes when the photographer is walking, secure the camera body to the photographer's chest with an elastic shock cord. One end of the cord can be removed to take a shot.

is dark. You have one hand on the tripod head and the other holding the camera and lens. How do you hold the flashlight? You could place the flashlight in your mouth, providing the light is small enough and it is not very cold, or you could use a headlamp. This relatively-inexpensive gadget frees your hands for doing what needs to be done.

☐ **Cable Release.** Why take the time to place your photography equipment on a tripod and then push the shutter release with your finger? That small action can cause camera movement, blurring the image. Instead, use a cable release, a piece of equipment as important as the tripod. Using a cable release "insulates" the photographer from the camera. A bulky finger does not press the shutter and, as a result, there is less vibration. Remember, vibration causes blur.

> "That small action can cause camera movement, blurring the image."

☐ **Strings and Wires.** When photographing flowers, you can bet something like a weed or grass stem will be in the way. Carry a piece of string, thin wire or similar material and the obstructing objects can be tied out of the way.

☐ **Light and Wind Diffusers.** You can count on a breeze as soon as the set-up is complete for a flower shot. To block the wind, a bed sheet can be secured upwind from the subject. In some cases, depending on the relationship of the sun to the subject, a white sheet will soften the light, often a desired effect.

☐ **Batteries.** Always carry spare batteries. Some cameras and other equipment are total-

ly battery-dependent. You don't need "nothing" happening when you push the shutter release.

☐ **Tools.** Nature photography can be tough on equipment. A multi-tool and jeweler's screwdrivers can be useful for making needed repairs and to tighten loose screws.

> ## "A small tape recorder can be valuable for recording data..."

☐ **Recording Data.** A note pad and pencil (ink in a pen can freeze) is nice for drawing diagrams or maps. Alternately, a small tape recorder can be valuable for recording data such as exposures, lenses, film type and ISOs used.

Gadgets are nice. When faced with a situation where they are needed, gadgets are more than a luxury – they are a necessity. In a short time every photographer develops his or her own list of gadgets to carry and hopefully shares those tips with fellow photographers.

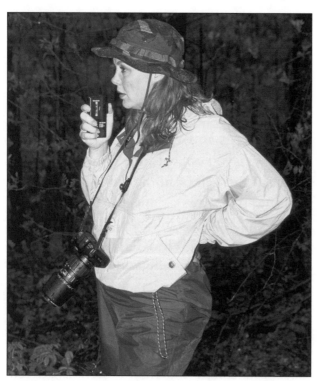

A small tape recorder can be used to create a memory aid, recording when, where and how a photograph was taken.

CHAPTER 2

Finding Your Subjects

The nature photographer does not have to be an expert to appreciate wildlife and the natural world. However, it does help to have an understanding of the subjects to be photographed. The more the photographer learns about the subject of his or her photographs, the more enjoyable and successful the total experience will be.

"It does help to have an understanding of the subjects to be photographed."

Furthermore, the successful nature photographer doesn't limit himself to learning only about the main subject to be photographed. When photographing birds, for example, it makes sense to study more than just the identification of the species. In addition learn the bird's behavior, the trees the bird frequents, the foods it prefers, migration paths, nest-building habits and appearance of eggs.

Television, computers and the Internet are useful research resources, but with the

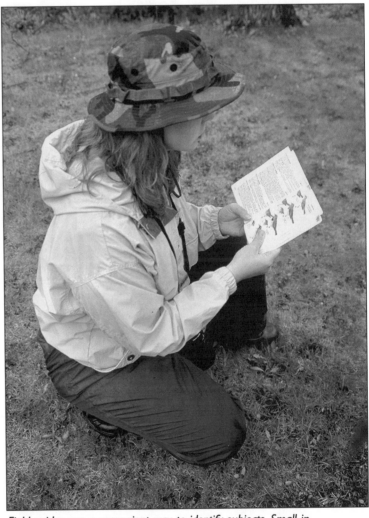

Field guides are a convenient way to identify subjects. Small in size, they will fit in most pockets. There are numerous field guides covering most subjects a nature photographer will encounter.

Above: Libraries offer many books that not only help the nature photographer learn about his subject, but his craft as well.

Right: Computer programs can help the photographer learn about nature. In addition to showing the subject and providing information, some bird programs will play calls and songs.

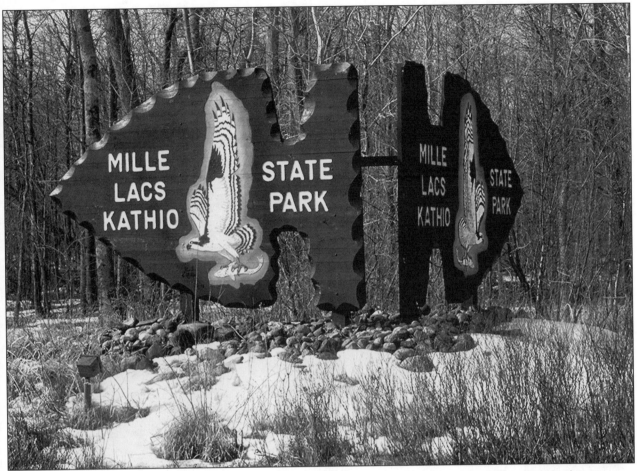

State parks offer a wealth of information. Park rangers or managers may be able to direct the photographer to areas frequented by the desired subjects.

emphasis on electronic information technology, it is easy to forget that books are still one of the most valuable "tools" available to the nature photographer. Books can easily be packed along into the field for reference during a photo shoot or can be used to research subjects before a shoot.

> ## "Field guides are small enough to be placed in a pocket for easy access..."

Reference books relating to wildlife and the natural sciences vary in size and price. Ideal for leisure reading are "coffee table" books, but these are probably too bulky for use in the field. Definitive textbooks can answer questions and give detailed insight on a particular subject, but again are not practical afield. Field guides are small enough to be placed in a pocket for easy access and quick consultation, and are available in a wide range of subjects. The field guide format provides a drawing or photograph for subject identification, while the text describes its physical attributes, measurements and often a description of range and migration.

With widespread access to computers, CD-ROM programs are a valuable resource. Many bird programs are available on CD, and can be used to identify a species both by physical description and the bird's song.

Top: Sometimes the best subjects may be common animals found in your own backyard.

Bottom: Bird feeders draw many species of animals, not just birds. Squirrels, chipmunks, black bears and other creatures can be a nature photographer's gold mine.

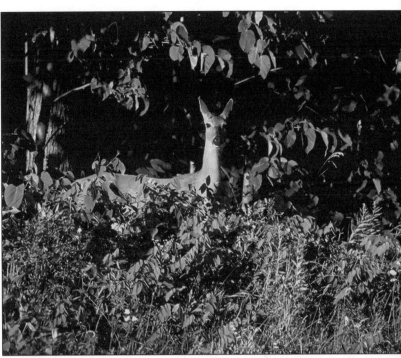

Right: Deer can often be observed near wooded areas, which provide cover and food sources. Bears frequent garbage dumps, while certain birds and mammals favor carrion.

Below: Tours can offer unique opportunities for the nature photographer.

Developing an interest in nature photography encourages the photographer to learn more about wildlife and the natural world. Developing an awareness of the natural world can make recognizing potential subjects one of the easier aspects of nature photography.

ZOOS, BOTANICAL GARDENS, PARKS AND REFUGES

☐ **Zoos.** Zoos hold a wealth of resources for the nature photographer. Located in or near most major metropolitan areas, zoos allow photographers to easily gain access to wildlife not normally seen in the wild (endangered, exotic and elusive species, for instance). Lighting is usually adequate, temperatures moderate for the photographer's comfort, and if the photo's composition is carefully considered, man-made elements in the final image can often be hidden. Zoos not only contain wildlife, but also plants and flowers. They also provide information about the animals being photographed.

> ## "Zoos hold a wealth of resources for the nature photographer."

☐ **Botanical gardens.** Botanical gardens and arboretums give the nature photographer the opportunity to observe and photograph many species of vegetation. Like zoos, these gardens are often located near larger metropolitan areas, and have a capable faculty willing to help the photographer locate and identify subjects.

☐ **Parks.** Parks not only draw people away from people, but draw wildlife away from people as well. City parks provide habitat for a variety of smaller mammals and birds, and offer the nature photographer numerous close-to-home photo opportunities. State and provincial parks, as well as national parks and forests, are home to both small animals and larger animal species – deer, moose, elk, bison, sheep, gray wolves and more. Park staff are a valuable resource and can provide maps and informational brochures to ensure a rewarding venture.

Do not hesitate to contact a conservation officer to find out if baiting is legal in the area you wish to photograph, whether or not you might be trespassing, and often where subjects may be found.

☐ **Refuges.** Wildlife refuges provide protection for animals within their boundaries. Some refuges are labeled on detailed maps; others can be located by contacting natural resource personnel or local conservation officers. Other nature photographers are often willing to share these little-known locations.

When taking advantage of these resources, it is imperative to be familiar with and abide by the rules that cover their usage. Zoos, for example, may prohibit the use of flash in certain areas. Arboretums may restrict travel to areas off the trail. Parks may limit access to certain areas during specific time periods, such as during a high-risk wildfire season. Motor vehicle usage in state and national parks may be prohibited in some areas. To avoid problems or negative encounters, ask first.

YOUR BACKYARD

Photographing close to home is not only convenient, but often can give the nature photographer great opportunities to capture remarkable images on film with 24-hour coverage. Most people live close to wildlife habitats or migration routes. A little investigation of your neighborhood will frequently yield positive results.

> ## "Most people live close to wildlife habitats or migration routes."

Working in a residential area, the photographer can utilize the house, porch or deck, garage or other buildings as a blind. Perches for birds and other forms of wildlife can be adjusted as needed to give more aesthetically-appealing shots. Feeders will often lure wildlife within the camera range of a patient and watchful photographer.

Sometimes a subject staring us in the face daily is overlooked. Commonplace sightings such as a singing robin, a feeding squirrel or a pretty goldfinch can be a photographic "gold mine."

TOURS AND WORKSHOPS

Tours and workshops help remove some of the hard work of finding subjects to photograph. Many opportunities are available and are advertised in photography and wildlife magazines. Animal sightings are almost guaranteed, and tour guides share their expertise not only in wildlife studies but, in some cases, photography as well. Tour companies strive to minimize environmental impact, and in some areas, specific routes are followed and the photographer's safety is assured.

UTILIZING LOCAL RESOURCES

Some nature photographers think of themselves as "loners," free as the breeze and very independent. That independence lasts until they run into problems or strike out when it comes to locating subjects or places to photograph. Take advantage of any resource presented. No one has all the answers, especially when it comes to nature and its photography. Resources vary with location. Listed here are some resources to consider:

☐ **Park managers** – Wildlife sightings, trail locations, regulations regarding park usage, resource libraries.

☐ **Conservation officers** – Wildlife sightings, conservation guidelines, area characteristics.

☐ **Naturalists** – Information regarding species and habitat.

☐ **Outfitters** – rail locations, equipment.

☐ **Libraries** – Field guides, CD-ROMs, comprehensive information on wildlife and area features.

☐ **The Internet** – Information on an endless range of subjects from animal behavior to map locations.

☐ **Sporting goods stores** – Hunting and fishing information, equipment, area maps.

☐ **Local residents and land owners** – Wildlife sightings, land use permission.

☐ **Bird clubs** – Species sightings and information.

☐ **Camera stores** – Equipment advice, accessories.

☐ **Nature learning centers** – Information regarding local wildlife and habitat.

☐ **Other nature photographers** – Photographic locations, shared experience.

CHAPTER 3

Getting Close to Your Subjects

BLINDS

One of the definitions of "blind" is to be hidden from immediate view. This can be accomplished in many ways, but probably the most comfortable and practical way to hide is to use a blind, especially when photographing subjects over an extended period of time. Blinds can be simple or complex, depending on location, resources and needs.

> ## "Blinds can be simple or complex, depending on location, resources and needs."

A simple blind can be created by placing camouflaged material over the photographer and his or her equipment. The camouflage is worn like a huge sack, holes can be cut in the material and a lens can extend through it. This type of blind is more portable than a structure-type blind, but space within the sack is limited.

A structure blind can be portable or permanent. A portable blind can be carried with the nature photographer, and can usually

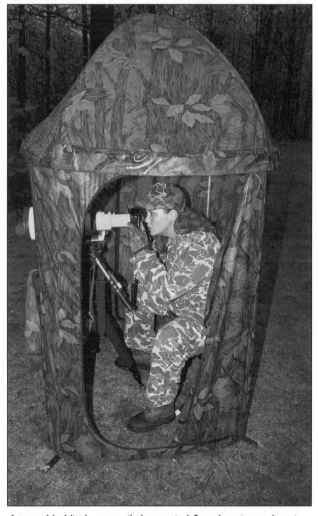

A portable blind can easily be carried from location to location. This type of blind should give the photographer enough space inside to place a stool, camera equipment and day pack, while providing a 360 degree range of vision.

Left: Mainly placed near sites frequented by wildlife, a permanent blind is usually constructed of heavier materials, and may even include shelves, offering more space for gear.

Right: A house can be used as a form of permanent blind. The photographer must still move cautiously in order to avoid spooking his or her subject.

be set up in a matter of a few minutes. This type of blind allows ample space for a stool to sit on and space to store equipment. The photographer can easily select and change camera bodies, lenses and film in this type of blind without being cramped.

A permanent blind is usually (and hopefully) constructed in an area where there are desirable subjects in sufficient numbers and with an adequate view to warrant the placement of the structure. A permanent blind can

be moved, but is cumbersome to haul a long distance.

> ## "Ideally, blinds should have an ample opening to enter and exit."

Ideally, blinds should have an ample opening to enter and exit. They should also have

windows that allow the photographer to observe and photograph in a range of 360 degrees. Remember, if you plan to see something in one direction, sure enough, it will appear in another. Some blinds have removable tops to allow the photographer to "jump shoot." This will result in a photograph, but most of the subjects will probably see the photographer and flee.

□ **Buildings and motor vehicles as blinds.** A building or motor vehicle can also be used as a blind, especially if the object is a common sight to the animals present in a par-

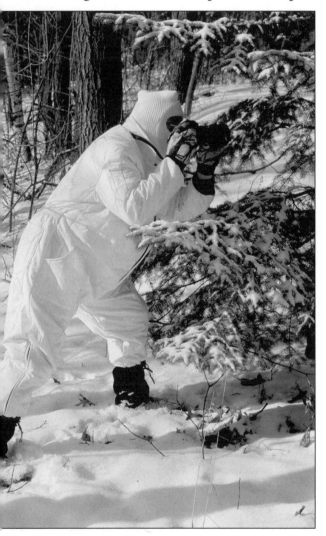

The purpose of camouflage is to blend into the surroundings. Many patterns of camouflage are available; choose one to closely resemble the conditions in which you will be photographing.

ticular location. Unfamiliar objects pose a threat to animals and spook them, so it is important that the photographer capitalize on what would appear "normal" in a given setting.

When shooting from a house or vehicle, the photographer still needs to be stealthy. Movements should be slow. If photographs are taken through a screen, the final image will probably be blurred. If taken through window glass, in addition to a blur, the final image may show reflections. Reflections can be minimized and sometimes totally removed by using a polarizing filter. An open window will probably give the photographer the best shots.

"When shooting from a house or vehicle, the photographer still needs to be stealthy."

A motor vehicle not only hides the photographer, but can also bring the photographer closer to his or her subjects. When setting up for a shot from a vehicle, turn off the radio, CD or cassette player, but consider leaving the motor running if this is how you first saw the subject. Often animals will stay put until the motor is shut off. Take the shots and then shut off the motor; hopefully the animal will stay for more photos.

Vibration causes movement. In a running vehicle, you may need to brace or cushion your camera and lens. Use a window mount, folded clothing, or place your arm across the top of the window and lay the equipment across your arm.

CAMOUFLAGE TECHNIQUES: CONCEALING THE PHOTOGRAPHER AND EQUIPMENT

The French word for disguise is camouflage. Nature photographers can disguise or conceal themselves by using camouflage to blend into their surroundings. Some animals are color blind, and camouflage helps conceal the photographer by limiting the movement visible to the subject. For animals that are not colorblind, camouflage simply helps hide the photographer. Camouflage helps the photographer get close to his or her quarry, and in some cases camouflage allows the photographer's subject to come to him.

> "Anything that can be seen by wildlife should be covered with camouflage."

Commercially-available camouflage or "camo" designs and colors are available in almost every conceivable design to blend in with every possible background. Nature photographers can probably settle for a few pattern designs to conceal themselves and their equipment. In most wooded locations, "woodland" camouflage, the green pattern worn by military personnel, is adequate. Late fall camouflage is brown and resembles the woods after the leaves have fallen and before new growth appears. This "camo" can be effective in corn fields and reeds if the general color scheme matches. In winter, white is the obvious choice. A winter camouflage is available that has branches or shadows imprinted on the material to make it blend into the environment to a greater extent. Whichever camouflage you choose, make certain it matches the surroundings as closely as possible.

Anything that can be seen by wildlife should be covered with camouflage. The photographer should be covered head to toe, and front and back. Items that may reflect light – eyeglasses, other personal effects and equipment – should be covered as well.

Sight, smell and hearing are the three main defensive senses used by wildlife. Six factors work together to provide effective camouflage:

- **Position** – Place yourself so that the background and foreground absorb your

With snowshoes, the photographer can reach areas where deep snow would normally prohibit access. Poles give stability and prevent the photographer from falling and possibly damaging photographic equipment.

visible presence. This works best if clothing colors match the colors of the surrounding area. Look for a site where camouflage will blend in.

☐ **Shadow** – When possible place yourself and your equipment in the shadow of a tree or boulder. Shadow helps provide camouflage. Consider varying camouflage in response to changing light conditions.

☐ **Color** – Even though some animals are essentially colorblind, it is important to attempt to blend in with the color of the surroundings. No one color does it all, but fine-tuning clothing colors to match the surroundings will give the photographer an advantage.

☐ **Movement** – Movement is what most animals see first. Keeping as still as possible

and avoiding sudden movement is to the photographer's advantage.

"Baits are used to lure a subject within camera range."

☐ **Sound** – Often caused by movement, sound is perceived as a threat to wildlife. It is almost impossible to sneak up on wildlife, but it can be done by constantly being aware of the sounds created by movement. Nature photographers use mechanical devices, and mechanical devices make noise. Consider buying cameras which feature quiet shutters.

With many calls on the market, it is possible to choose the one that will draw a selected subject in to be photographed. Practice is required to be proficient in calling wildlife. Pictured from left to right are: deer grunt call, mouse call to draw in animals that feed on mice, duck call, wounded rabbit call to draw in coyotes or fox, songbird call, and a turkey call.

Be aware of the noise your equipment makes and try to minimize it.

☐ **Smell** – Avoid using cologne and other aromatics such as tobacco. Unscented soaps and shampoos are available and might be a consideration. Because of the odor imparted into the fabric, fabric softeners should not be used when laundering outdoor clothing. Consider the wind direction and, if possible, place yourself with the wind coming toward you. This should carry your scent away from your subjects.

ATTRACTING YOUR QUARRY

Often it is easier to have photographic subjects come to the photographer, than it is for the photographer to get to them. Baiting, calling and the use of decoys are three ways to accomplish this.

> ## "Always ask a conservation officer if it is legal to set bait..."

Often deer can be attracted by "rattling." Clashing two sets of shed antlers together for a few seconds will attract deer who believe the sound is made by two bucks fighting for territory.

☐ **Baits.** Baits are used to lure a subject within camera range. The types of wildlife to be photographed determine the types of bait used. Some baits may have to be supplied by the photographer, while others may already be present in the environment. If black bears are the photographic subject, it may be beneficial to bait them with bakery goods, anise flavoring and bacon grease. A black bear, especially in the autumn, will be preparing for dormancy and will be attracted to such "goodies."

Whitetail deer may be drawn in with corn or other grain. For deer, corn fields represent bait present in the environment; for the black bear, a garbage dump offers the same attraction. Song birds are easily baited by using a bird feeder. Other birds, such as raptors and crows, might be drawn in by setting up a blind near a cadaver or the carrion of some other creature.

Always ask a conservation officer if it is legal to set bait and seek land owner permission before doing so. In some areas it is illegal to bait animals and in most areas trespassing is illegal.

☐ **Calling.** Calling is another method of attracting wildlife and can be used alone or in conjunction with baiting. Calling is a skill that can take years of practice to master. When calling, the goal is to imitate either the call of the subject, the animal's potential mate, or the call of its prey species.

Animals do have a language, and to fully understand and imitate that language requires extensive study. Numerous books, audio tapes and CD-ROM programs describe and provide recordings of animal and bird sounds. Through repeated listening, some of these sounds will become recognizable. With practice it is possible to imitate animal language utilizing the proper calls. When it comes to learning to recognize sounds and other animal signs in a specific area, a "field trip" with an experienced naturalist or outdoorsman can be a valuable tool.

Calls can be produced vocally or by using mechanical devices – either manufactured or homemade. They include:

☐ **Deer** – Deer "grunts" and "rattling," a technique that imitates two bucks fighting over breeding territory, may attract animals.

☐ **Waterfowl** – Numerous duck and goose calls are on the market, but a mallard call lures many species of duck. For geese there is an all-around call for attracting Canadian, blue and snow geese.

☐ **Turkey** – Turkey sounds are imitated using a two-piece friction call or a mouth call. The advantage of mouth calls is that they can be produced without any movement of the hands.

☐ **Predators** – The most common predators lured by calling are coyotes, bobcats and foxes. Using a call that imitates a dying rabbit or mouse (a potential food source for the predators) often will bring results.

☐ **Decoys.** Still another method of bringing wildlife to the nature photographer is to use decoys, an image of an animal or bird that acts as a lure. Decoys can be used in conjunction with baiting, calling or camouflage techniques.

"Decoy setting and placement is determined by geographic location and time of year."

When selecting and using decoys, certain elements should be considered. Obviously, decoy colors selected should match the color of the desired subject or its potential mates. The plumage of some birds changes color with the seasons. During breeding season, some males exhibit more vivid coloration. Colors change during molting, the period when the bird's feathers drop and are replaced. Some birds develop their characteristic coloration over a period of years. The bald eagle, for example, is completely brown until its fourth year, when it develops its characteristic white head and tail. When it comes to waterfowl (which have excellent eyesight), numerous species exhibit various color phases. Be selective in your choice of decoy colors.

The shapes of the decoys are another consideration. Most often the shape of the individual decoy purchased is appropriate. However, goose decoys are available which imitate the shape of ground-feeding birds. Not only does this entice other geese to land because of "company," but in addition, draws them into a feeding site. Once the birds have

Finding tracks means that wildlife has been in the area. With experience and reading, the photographer will be able to identify the animal that left the tracks and determine the time the tracks were made.

landed at a feeding site, they will sometimes be too occupied with eating to notice a photographer hiding in the shadows.

> ## "It makes sense to set decoys in areas where the desired subject can be found."

Decoy setting and placement is determined by geographic location and time of year. It would be as absurd to set waterfowl decoys in the middle of the woods as it would be to set a turkey decoy in the middle of a lake or in geographical areas where the desired birds rarely appear. Place decoys in a location that is frequented, or likely to be frequented, by the subjects you wish to photograph.

It makes sense to set decoys in areas where the desired subject can be found. It also makes sense to set them when the subjects will be present. Depending on where they will be photographed, migrating birds, for example, might be more prevalent during the spring and fall. Consider the four major waterfowl

Finding an animal path can be an exciting opportunity for the nature photographer. Setting up a blind or stand in an area close to, but not on the path, can yield success.

flyways in North America – The Atlantic Flyway, Mississippi Flyway, Central Flyway and the Pacific Flyway. Certain wildlife species are more predominant during certain times of day or night. Plan decoying to draw the subjects closer to the camera when they are most likely to be present in the general area.

TRACKS AND OTHER SIGNS

Often the signs a wild animal leaves in its path will lead the photographer to it. The most common sign is the animal's tracks. Tracks can give the photographer information regarding the species, size and gender of the animal, as well as direction of travel and how recent the animal passed through an area. Tracks, scat and other signs left by wildlife can lead the photographer to areas where certain species congregate and therefore provide a greater chance at getting images on film.

Some animal tracks are easy to identify. The whitetail deer's tracks should be obvious to most, especially in areas where other hoofed animals are not common. A look in a book on animal tracks will reveal the obvious similari-

ties of the whitetail deer, the black-tailed and mule deer. Add to that the tracks of other hoofed animals like the moose, elk and sheep, and greater confusion is possible. To help avoid the confusion created by attempting to identify various animal tracks, it is recommended that the nature photographer add an animal track field guide to his or her collection of books.

Whether hunting wild animals with a firearm or a camera, the "hunter" needs to be stealthy. The same techniques of using blinds, camouflage and attracting wildlife apply to both wild game hunters and nature photographers. Wildlife are wary. To get that shot, the photographer must apply the same use of equipment and technique as a hunter.

> "... paths are subtle
> and may be
> harder to identify."

Paths are another sign left by some wildlife. In winter when there is snow, paths are obvious. Where there is no snow, paths are subtle and may be harder to identify. Generally, wildlife use their paths early or late in the day; these times yield the best views of animals in transit. Since human odors may spook the path "owner," travel on animal paths is not recommended.

Safety Issues

SAFETY ISSUES

A general knowledge of animal behavior will provide the photographer with a "safety net" while working in the wild. Specialized photo equipment, such as telephoto lenses, can remove the risk created by venturing too close to potentially-dangerous animals.

> "... bears probably
> spark the
> most concern."

☐ **Bears.** Of all the "wild creatures" out there, bears probably spark the most concern. Four species of bear are indigenous to North America—the black, grizzly, Alaskan brown and the polar bear.

The most common North American bear, the black bear, measures about five to six feet long, two to three feet tall at the shoulders and normally weighs up to a little over 475 pounds. Its range is throughout most of Canada and Alaska, down the west coast of the United States to mid-California, throughout the Rocky Mountain states, northern

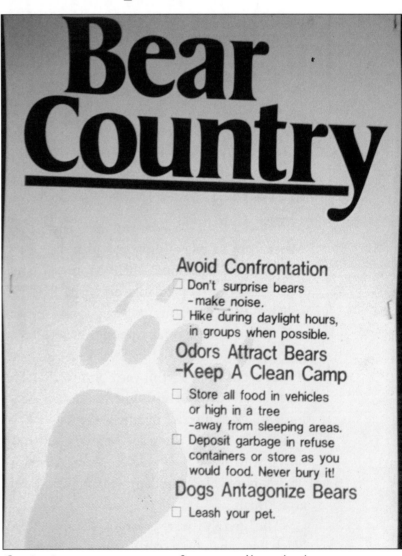

Certain circumstances are cause for concern. Always heed posted warnings.

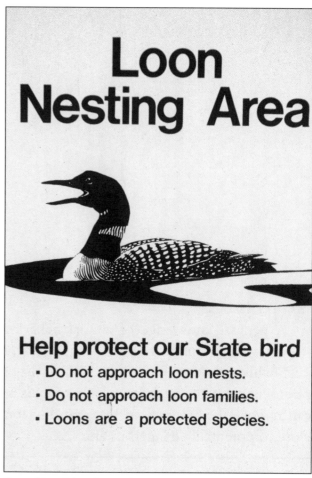

Some signs provide safety to the observer, while some provide for the safety of the observed.

Minnesota and Wisconsin, up the lower Mississippi River regions, Florida, New England and the Appalachian Mountain area. The black bear is primarily nocturnal and is a solitary animal, eating berries, nuts, insects and larvae and, as many people have discovered, garbage from the backyard can, or sunflower seeds from a front yard bird feeder. The black bear has poor eyesight, moderate hearing and a good sense of smell. Occasionally it will attack young domestic animals and raise havoc with some domestic crops and beehives where honey is abundant. They very rarely attack man.

The grizzly bear, a larger cousin of the black bear, measures six to seven feet long and three-and-a-half feet tall at the shoulders. It weighs in between 325 and 850 pounds.

Grizzlies range across most of Alaska, the Yukon, western Northwest Territories, British Columbia, the western edge of Alberta, and down the Rocky Mountains to northern New Mexico. This bear prefers twilight, but can be on the move at any time. Its preferred diet includes grasses, berries, mice and salmon, when they are running.

> ## "The black bear is primarily nocturnal and is a solitary animal..."

The Alaskan brown bear measures about eight feet long, four to four-and-a-half feet tall at the shoulders, and weighs up to 1,500

To avoid man-bear confrontations, maintain as much distance as possible. If confronted, don't run because the bear will catch you if it wants to. If attacked, try to remain calm and lie down, assume the fetal position and cover your neck. Resist only as a last resort.

pounds. The range of this solitary bear is near the southern and southeastern coasts of Alaska. It is active both night and day and, like the grizzly, dines on grasses, berries, mice and running salmon. Again, unprovoked attacks against man are rare.

The polar bear, on the other hand, is always dangerous and always unpredictable. The polar bear (or *thalarctos maritimus*, which means "sea bear"), is called "nanook" by the Inuit. At the shoulder it measures three to four feet tall, and on average weighs from 600 to 1,100 pounds. At least one bear weighing 2,000 pounds and standing ten feet tall has been recorded. This makes the polar bear one of the largest, if not the largest, land carnivores on Earth.

To avoid a man-bear confrontation, maintain as much distance as possible and make your presence known. If you do encounter a bear, look for an escape route for the bear. Never corner a bear. Since bears are attracted to garbage, good housekeeping is a must for campers, hikers and nature photographers alike. All food should be securely covered and, ideally, cached out of a bear's reach. Feeding bears is an invitation to problems.

If a confrontation should occur, don't run. The bear will catch you if it wants to. Instead, make loud noises by banging metal objects or blowing a whistle, for example. If a group of people is present, gather into a tight formation. This may be imposing to the bear. Avoid eye contact since the bear may perceive this as a threat. Throw rocks near, but not at, the bear.

If worse comes to worse and a bear attacks, try to remain calm, drop to the ground, cover your neck and assume a fetal position. This will protect as many "vital" areas of your body as possible. Resist only if needed and then fight like hell, using sticks, rocks, a knife, etc. The choice is yours, but if there is no escape and you must stand your ground and fight, an extended tripod might send a message to an attacking bear (or he might eat it).

Some sources indicate that red pepper spray is effective in deterring a bear attack. The fact is, pepper spray is effective only if sprayed directly into a brown or grizzly bear's eyes and nose. Another consideration is that the propellant of the spray is often water which acts as an antidote of sorts and does not leave the spray's stream for up to twelve feet. Spraying a bear that is within close range may not only be ineffective, but may have dangerous results.

"The black bear is primarily nocturnal and is a solitary animal..."

Once pepper spray is used, the odor will remain in an area for some time. Since the odor of pepper spray may actually attract bears, it is important to dispose of the spray canister after use. Additionally, to avoid experiencing the irritating effects of pepper spray, downwind contact, inhaling the spray or touching anything that has come into contact with the spray should be avoided.

All bear encounters and attacks should be reported to a conservation officer. "Problem bears," animals that show aggressive behavior or pose a threat, are monitored and may have to be moved to another area. If it is determined that a certain animal is a danger to humans, it will often be live trapped and moved.

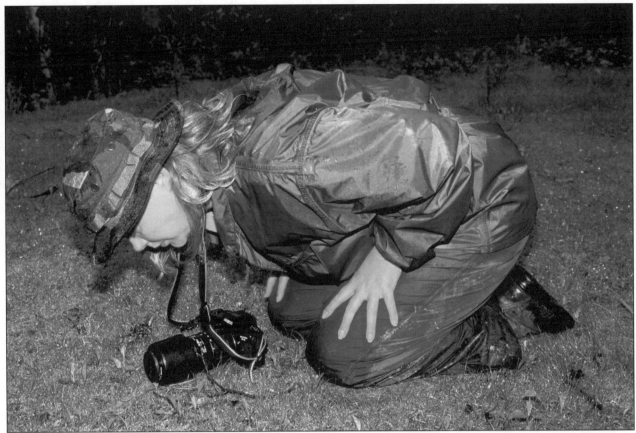

If caught in an electrical storm and if your hair stands on end, a possible lightning strike is imminent. Lie down, bending forward holding your knees in your hands. This position keeps you low to the ground and minimizes your body's surface contact with the ground.

☐ **Snakes.** Snakes are another concern of the nature photographer. About 115 species of snakes reside in North America; only about twenty are venomous. In the United States an average of ten fatalities a year are the result of snake bites. While most regions of the United States have venomous snakes present, the farther south one travels, the greater the chance of encountering a poisonous snake.

> "If bitten by a snake, assume it is venomous."

Most snake bites occur when the temperature is above 70 degrees F. Snakes become relatively inactive when it is cool. The two biggest tips to avoiding snake bite are: 1. Be careful where you walk and where you reach; and 2. Never handle venomous snakes.

If bitten by a snake, assume it is venomous. While there is some debate as to the medical treatment of a snake bite victim, certain emergency care procedures are not subject to debate. Seek medical attention and advice as soon as possible. Keep the victim still and calm and conserve body heat. Cleanse the area of the bite with soap and water, remove any jewelry from the bitten extremity and keep the affected area immobile.

☐ **Lightning.** Lightning is one of nature's most beautiful and dramatic sights. Photographers who attempt to capture the drama of lightning, or the beauty of nature

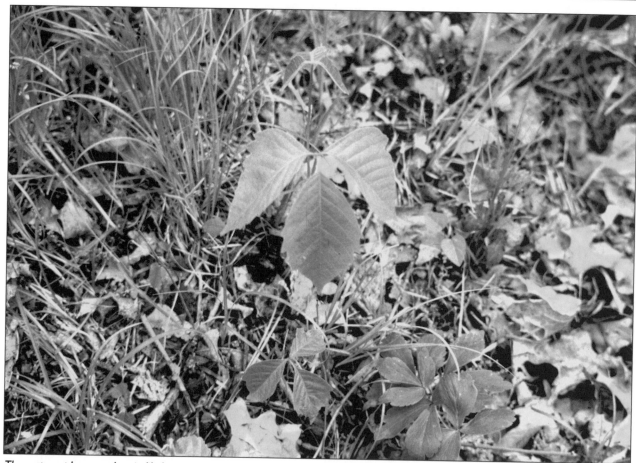

The nature photographer is likely to come into contact with poison ivy, a common poisonous plant. Those vulnerable to poison ivy should avoid contact. If itching or blistering of the skin occurs, wash the affected area with soap and water and seek medical attention.

while lightning is present, should be aware of the potential danger lightning presents. On the average, lightning kills just over a hundred people in the United States each year. Caused by the interaction of charged particles producing electrical fields in clouds, lightning can strike from cloud to ground, cloud to cloud, or ground to cloud. The temperature around a lightning bolt can be six times greater than the surface of the sun.

If caught in an electrical storm on a lake, river or other body of water, get off. Stay away from trees. If a vehicle is close by, get inside, but realize that four radial ply tires are not going to slow down 200,000 amperes of electricity. Stay away from metal fences and high ground.

> ## "Do not lie down, but assume a fetal position."

If you find yourself caught outside in a lightning storm and your hair stands on end, a close strike is imminent. Do not lie down, but assume a fetal position. Get down on your knees and bend forward holding your knees in your hands. If you are inside a dwelling during a lightning storm, stay away from electrical equipment and appliances, including the telephone. Baths and showers will have to wait.

If someone is struck or nearly struck by

A bug suit will prevent insects from coming in contact with you. Since the suits are warm, it is advised that exercise be kept to a minimum to avoid overheating.

When it comes to poisonous plants, the best prevention is avoidance. Learn to identify the plants in all seasons and avoid contact. If exposure to a poisonous plant occurs, first remove the victim from the offending plant. Next, wash the affected areas with soap and water. A dressing should be applied to blistered areas. Several over-the-counter medications are available to combat the irritation, but if the condition worsens or swelling becomes extreme, seek medical attention.

"... insects can turn a pleasant outing into a torture session."

☐ **Insects.** Years ago, survival "experts" were placed in Minnesota's Boundary Waters Canoe Area Wilderness. They were exposed to summer heat and humidity, winter's harsh cold and winds. Their tasks included foraging for food, procuring water and building shelter. They were also confronted with bugs, and the bugs won grand prize as the ultimate challenge faced.

For the nature photographer, insects can turn a pleasant outing into a torture session. To avoid insect-related unpleasantness, use either an insect repellent containing DEET (follow all insect repellent instructions), or wear a bug suit. Both methods help control pesky insects. DEET-containing repellents are often characterized by an odor that is not conducive to stalking animals, and for some, bug suits do not afford adequate ventilation, so the choice becomes a matter of personal preference. Some people swear by certain skin softeners or ultrasonic devices... others swear at them.

lightning, provide immediate resuscitation and then treat for other injuries such as fractures and burns. Lightning strikes are almost always fatal. Near-strike victims must have medical attention for possible underlying problems.

☐ **Poisonous Plants.** A more passive threat than bear attacks, snake bites or lightning is exposure to poisonous plants. In the United States the most common poisonous plants are poison ivy, poison oak and poison sumac. Exposure to these plants can cause itching, swelling skin and sometimes blistering. Allergic reactions can be severe in some people.

Left: A nest is a trustworthy indicator that potential "problem" insects are in the area. Avoid a dangerous situation by leaving the area. If you insist on photographing these subjects, take advantage of telephoto lenses.

Above: For those who have known allergies to insect stings or bites, an allergy kit should be included with medical supplies.

In addition to the unpleasant conditions created by insects, some insects are dangerous. Bees are able to inject venom, and venom is a poison. Most people who are allergic to bee stings are aware of their reaction to bee venom. Others are not. The treatment for someone who has been stung by a bee is the treatment for shock. This may seem extreme, but it is important to realize that the symptoms may present themselves immediately or sometime later. Allergic reaction to bee sting can include breathing trouble and even death. If the bee's stinger is embedded in the victim's skin, do not remove it by pulling. This proce-

dure could inject remaining venom into the victim. Instead, scrape the stinger from the victim with a credit card or a similar stiff, but flexible object. If the victim is carrying medications for the purpose of treating an insect bite or sting, help him or her administer them. For any suspected insect poisoning, seeking medical attention is a must.

Lyme disease, caused by the bite of a deer tick (which is about the size of a sesame seed), affects the nervous system, joints, heart, skin and other body parts. Early stages of the disease may include a rash, fatigue, fevers and chills, muscle aches and swollen lymph nodes.

Later symptoms may include stiff neck, headaches, persistent fatigue and irregular heartbeat. Early diagnosis and treatment with antibiotics can often alter the course of the disease.

Prevention of tick bites includes tucking pant legs into socks. Avoid wearing shorts in wooded or grassy areas. DEET can be a helpful preventative.

> ## "Prevention of tick bites includes tucking pant legs into socks. "

If you find a tick attached to the skin, grasp it close to the skin and pull it out slowly, avoiding any jerking movement. A magnifying glass is a handy tool here, and in the field a 50mm lens makes a good substitute. Remove the lens from the camera body and look through it from the direction it attaches to the camera. (This works great as a magnifier and a loupe at the light table, as well.) If the bite of a deer tick is suspected, it is wise to be seen by a physician.

□ **Ice Dangers.** Nature photographers who find themselves on frozen lakes and rivers will have their day ruined if they fall through into frigid waters. Be aware of ice conditions to ensure a safe outing. Avoid the ice if there is any doubt about its safety.

There is no guarantee that any ice will be safe for traveling. Ice can vary in thickness by ten inches for every ten feet traveled. Ice that appears cloudy is possibly weak due to ice bubbles. Black or blue-green ice is possibly safe for travel. Ice covered with heavy snow may not be safe, since snow acts as an insulator, and water underneath can melt the ice above. Ice

Here's one sign that's self-explanatory!

with water on top due to melting snow or ice can be weak from the extra weight and could crack. Sunny, warm days can cause ice to melt, and warmer-than-usual water below can melt the ice, again causing weak areas.

Weeds and grasses may indicate weak ice because heat is created as vegetation decays. Dirty and polluted waters freeze slowly. Rocks and piers often have weak ice around them. Strange as it may seem, ice on the south side

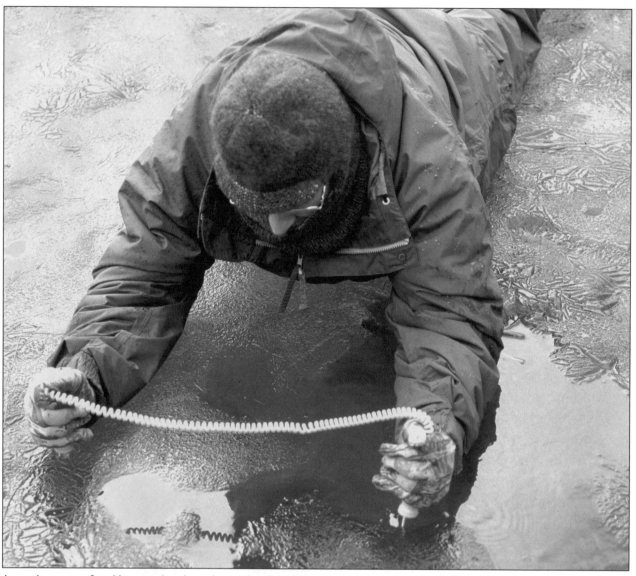

Ice awls are comfortably carried and can be used to "grip" the ice, allowing a person who has fallen through the ice to climb out of the water and onto the surface.

of a lake is sometimes weaker than on the north. Lake inlets and outlets usually have weaker ice, and river ice is ten to fifteen percent weaker than lake ice. River bends are weaker yet.

The best indicator of ice safety is its thickness. General rules are: Less than four inches – STAY OFF! Four inches is okay for ice fishing or skating, six inches is okay for snowmobiles, eight to twelve inches will support a car or small pickup truck and twelve to fifteen inches or thicker is okay

for medium-sized trucks. Remember, ice thickness varies!

As usual, prevention is the best medicine. Make sure ice is thick enough before venturing onto it. As a precaution, work with a partner. Wearing a PFD (personal flotation device or life jacket) may seem strange in the winter, but could save your life. The PFD acts as a jacket of sorts, preventing heat loss when on the ice and, should you fall through, in the water as well. Carry a pointed object while walking on the ice. Screwdrivers, keys, big

nails or similar items can be used to jab the surface of the ice to help you crawl out of the water should you fall in.

> ## "This is also one time when wearing a seat belt is not encouraged."

If you are traveling in a vehicle on the ice, it is best to carry a PFD with you, but not to wear it. This is also one time when wearing a seat belt is not encouraged. Both the PFD and the seat belt could hinder escape from a vehicle that has fallen through the ice. Keep the windows down and the doors slightly open when driving on ice; these will also aid escape. Since passengers have only seconds to react when a vehicle goes through the ice, it makes sense to mentally and physically prepare for such an emergency.

If you should fall through the ice, climb out of the water, roll away from the hole and follow the path that led you onto the ice, since that ice route has already been tested. Be prepared! A second trip could cause the ice to weaken and allow you to fall through again. Once to shore, seek treatment for hypothermia. As soon as possible seek shelter, get out of wet clothing and consume hot liquids.

If you are with someone who has fallen through the ice, use a rope to help rescue him from the water. Anything buoyant can be used as a flotation device – coolers, boards, bait buckets and, of course, life jackets. If possible call or have someone call 911. Emergency medical services and dive teams will be notified immediately.

The bottom line is that no ice is guaranteed to be safe ice. If there is any doubt about

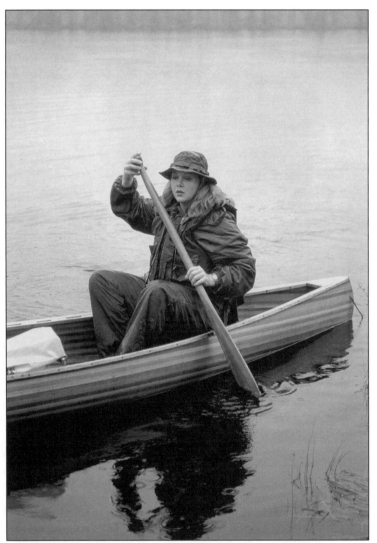

While in, upon or near water, a personal flotation device (PFD) is a must. Not only will it keep you afloat, it will aid in the prevention of hypothermia.

the condition of the ice, stay off and attempt to reach your photographic subject by another route or by using telephoto lenses.

■ **Near Drowning and its Prevention.** Since nature photography includes a portion of water-related subjects (waterfowl, marine animals, waterfalls, etc.), sooner or later a nature photographer will find himself on or near the water.

There are two main contributors to drowning accidents. The first is excessive consumption of alcoholic beverages; and the second is not donning a PFD (personal flotation

A survival kit should contain material to provide shelter, construct a fire, procure safe water, signal help and furnish a food source. Matches, a knife, some line, a compass, whistle, flashlight, multi-tool, insect repellent and toilet paper should be included.

device). Both factors are avoidable. Every year about 150,000 people drown, 7,000 in the United States alone. Ninety percent drown within ten yards of safety. In adult drownings other contributing factors include boating mishaps, poor or no swimming ability, injuries, medical problems, bad weather, being alone and cold (hypothermia). Preventative measures can help ensure that the nature photographer's outing on or around the water is both safe and successful.

Aside from his or her camera, a personal flotation device (PFDs) is probably the most important accessory a photographer can have when working from a boat. There are four basic types of PFDs, but for special purposes like photography, the Type III PFD is the most versatile. This type of PFD is foam filled and styles include vests and full-sleeved jackets that offer protection against immersion hypothermia. This is an important factor to consider since, in water, body heat is lost at a rate up to thirty times greater than in air.

Hypothermia occurs when body heat is removed by immersion in cold water. The onset of hypothermia can be postponed by adopting the HELP (heat escape lessening posture). While wearing a PFD and with the

head out of water, the arms are crossed in front of the chest and the knees are drawn up. This posture minimizes the loss of body heat. The photographer working alone is more at risk than one who works with a partner. In the event of an accident, help is at hand or, at least, help can be summoned. When photographing or enjoying nature, the safest and most congenial approach is to work and travel with a buddy.

> "... plan photo shoots according to weather conditions."

■ **Weather.** Nature photographers work outdoors and at the mercy of weather conditions. Weather and temperature extremes are murder not only on camera equipment and film, but on photographers as well.

To minimize stress on the photographer and wear and tear on equipment, plan photo shoots according to weather conditions. Check the weather forecast and current conditions for both the location of the shoot and for the route to the site as well. Weather information is easy to come by – most photographers have access to a vehicle radio, TV weather channel, the Internet or NOAA (National Oceanic and Atmospheric Administration) radio. Any of these sources should provide accurate weather reports and forecasts. Heed these forecasts. It is better to postpone a shoot in favor of a safe and pleasant outing, rather than risk a potentially dangerous situation.

CHAPTER 5
Survival Skills

SURVIVAL SKILLS

The word "survival" means many different things to different people. Some envision being adrift on a life raft in the middle of the ocean without rations. To others, it could mean crawling across the desert without water. To still others, it could mean being home with a house full of kids and a broken VCR.

> "... there are some things the body cannot withstand... "

In reality a true survival situation is more likely to be the result of becoming disoriented and lost in extreme weather. With proper preparation and adequate information the nature photographer can avoid finding himself or herself in a survival situation in the first place and, if the situation does occur, can find a way out of the situation.

SURVIVAL ATTITUDE

The human body is tolerant and resilient and, to a degree, can bounce back from certain insults. However, there are some things the body cannot withstand – a drop in body temperature, lack of food or water for an extended period of time, injury or medical emergencies. When it comes to survival, you HAVE to remember that you MUST survive, and that you CAN survive. In a crisis, training and a positive attitude could mean the difference between life and death.

Picture this: a photographer starts out early in the morning, and drives about 140 miles to a state park he visited a year ago. En route he listens to his favorite tape on the cassette player, not to the news and weather. When he arrives at the park, he parks his car in the designated lot, unloads his photography gear, and heads out to a section of a river that he canoed last year. The hike to the river follows a meandering four-mile trail. Along the way the photographer decides to leave the trail, looking for a shorter, more direct route to his destination.

The photographer brings along camera gear, but nothing else. The clothing he is wearing is comfortable for high noon in early October. He is excited about the photographic opportunities that await – the colors are

spectacular and, despite the clouds building in the west, the light should be about right when he gets to the river. He plans to return to his car near dusk.

The trail the photographer left half an hour ago is now long gone. No sounds can be heard from the river, and the trees hold enough leaf cover to hide any landmarks. Without a map or compass, the photographer doesn't know where he is or in which direction he is heading. The hike has made him thirsty, and his stomach is beginning to protest the lack of sustenance. Before long, dusk settles, then darkness. The air temperature has moved beyond cool and dampness fills the air. It is cold, much colder than he expected. This photographer's situation is an invitation to disaster.

> "Avoiding a survival situation can be more important than knowing how to get out of one."

Avoiding a survival situation can be more important than knowing how to get out of one. In this scenario our photographer could have done certain simple things to avoid becoming lost in the first place. Before starting out he could have packed a map and a compass, told someone where he planned to park his vehicle, his intended route, and the time he expected to return. If he was late in returning, a search could have been started.

Planning ahead and packing clothing to meet the needs of changing weather conditions would have been wise and could have changed the scenario considerably. Our photographer should have listened to the weather forecast and, with an awareness of oncoming

weather, could have postponed his jaunt or dressed accordingly. A pocket full of candy and a canteen of water provide more than just comfort; to the photographer on his long hike they would offer fuel to keep him going.

Now imagine you are the photographer in trouble. If faced with a potential survival situation, the first step is to remain calm and STAY PUT! Panic causes mistakes and mistakes can have deadly results. Panic can cause the disoriented individual to run farther from the starting point or the destination. Panic and running may cause perspiration, which in turn can lead to hypothermia, a dangerous drop in body temperature. Admit you are lost and stay put to avoid becoming "more lost." Once admitting that a "situation" exists, most of the battle has been won. Check pockets, camera bag and packs for potential life-saving items.

■ **Shelter.** Shelter from the elements helps maintain body temperature and is often the most important survival need. Temperature extremes can kill, and being caught off guard without proper clothing doesn't help. The human body can tolerate little change from its

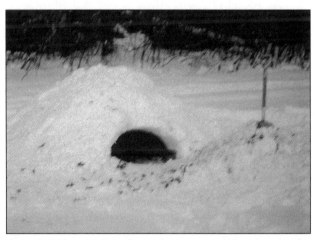

A snow shelter is relatively simple to construct. In a large circle, trample the snow to ground level and then pile the snow in the center. Wait an hour and shovel out the inside to conform to the outside shape, leaving a wall a few inches thick. Heat is created from the earth, your body and any other small heat source that might be available.

normal temperature of about 98.6 degrees. Hypothermia is a leading killer in the out-of-doors.

Shelters can be constructed from clothing, materials found in the surrounding environment or from supplies carried in a survival kit. Aluminum rescue blankets, which are small and easier to carry in a survival kit, can help provide shelter from the wind, snow or rain and can be tied between trees for protection from the elements. Since aluminum conducts cold and is non-permeable, rescue blankets are not used like conventional blankets, but instead are used as windbreaks and moisture barriers. Two rescue blankets and a few feet of rope can be fashioned into a fairly decent shelter. Imagination is a useful tool when it comes to devising shelter.

In the woods, limbs or branches can be leaned against a dead-fall or canoe, or a stout branch can be placed in the notches of two trees and more branches piled against it. Pine boughs give a nice finishing touch since they tend to fill gaps, preventing moisture and wind from entering the shelter.

To provide protection from the elements in a snowy environment, a "Quin-zhee" shelter can be built. The process is simple, but it is important to work slowly to avoid perspiring. First the snow is trampled to ground level in about a ten-foot circle. Using any available implement, shovel snow in the center of the circle to a four- to five-foot dome-shaped mound. Now wait a couple of hours to allow the snow to crystallize. Use this time to gather firewood, build a fire and rest. In about two hours, tunnel into the pile of snow through an opening just large enough to enter. Excavate snow from the inside, leaving a three- to five-inch thick wall. If light can be seen through the inside walls, the walls are becoming too

thin. Scrape the snow as close to the ground as possible.

Next, make a door that is *not* air-tight out of a block of snow; with a branch, make a two-inch diameter hole in the rooftop for ventilation. With just a candle, the heat from the earth, and body heat, the temperature inside the shelter should be high enough to cause a slow melt. Make sure the interior walls are smooth and that there is a trough for melted snow to run down and out the door. The drawbacks to the "Quin-zhee" shelter include the possibility of collapse and the fact that it is essentially camouflaged. A loose-fitting door for ventilation and an emergency exit are important considerations.

> ## "... hypothermia can set in at temperatures of just 60 degrees Fahrenheit."

Hypothermia can set in despite adequate shelter, a source of heat and dry conditions. Especially in windy or wet conditions, hypothermia can set in at temperatures of just sixty degrees Fahrenheit. The first sign of hypothermia is shivering, the result of the body's attempt to make heat. Heed this warning and seek a dry, warm shelter. As the body temperature drops, shivering stops and no body heat is created. Heat must be added, either by sharing the body heat of another in a sleeping bag, for example, or by using an external heat source, such as a fire.

☐ **Fire.** Fire is not only a source of heat, but in addition can fend off insects, act as a signal and provide the comfort of a good friend. Heat, oxygen and fuel, in proper proportions, make a fire. For the nature photog-

rapher, rubbing two sticks together or striking flint and steel isn't practical, but packing a reliable source of flame (matches or a butane lighter) is a simple precaution. Pack matches in a waterproof container such as an empty film canister, add a striker, birthday cake candles (for a longer lasting flame), and a small amount of toilet paper (for dry tinder), for a simple emergency precaution.

To build a fire gather more tinder, kindling and fuel. Tinder can be the dry nests of birds or rodents, leaves, birch bark, paper and the like. On top of the tinder, add kindling (twigs and small branches). Light the fire and once it is going, add fuel (larger material). A draft adds oxygen, but since too much will blow a fire out, a windbreak may be necessary. Don't go overboard with a fire, especially in dry conditions. As simple as fire building sounds, it is important to learn this skill by practicing before the need arises.

"Contaminated water can make you sick …very sick."

☐ **Water.** Water is another important survival item. The simplest and safest way to provide water is to carry it along. In moderate temperatures a small canteen will provide enough water for a short outing. When water supplies are limited, conserve water by breathing through the nose, not the mouth, which removes moisture from the body. Avoid perspiring. If the water supply is exhausted, prepare safe water for drinking by boiling, filtering or chemically treating water from a nearby creek, river or lake. A rule to follow is: "Ration perspiration, not water." In hot and

Water, no matter how pure it seems to be, can make you very sick. Either boil or filter available water, or bring water from a known safe source.

cold weather, large quantities of water must be consumed.

Contaminated water can make you sick… very sick. Boiling is one method of sterilizing water. A hard boil for ten minutes, plus one minute for every 1,000 feet above sea level, does the job. Two drops of bleach per quart of water or one water purification tablet per quart (follow the instructions that come with the tablets), both doubled if the water is

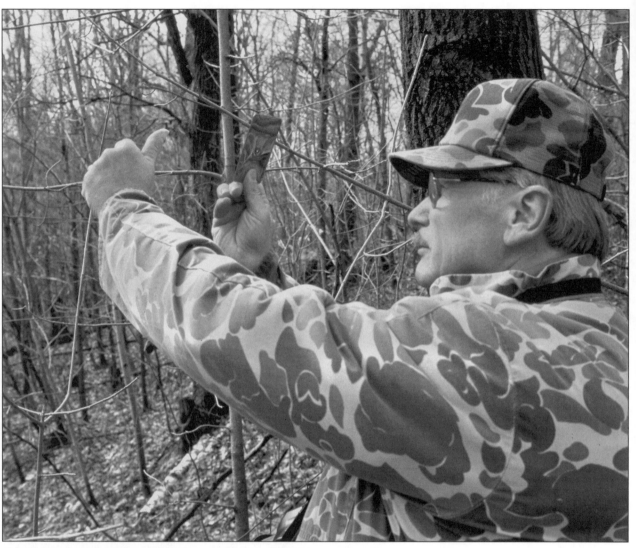

Compact and easy to use, a signal mirror can be aimed at a place or rescuers.

cloudy, should also do the trick. Filtration is the simplest method of providing safe drinking water. A water filter that is used like a straw is available and easy to pack.

> ## "... it takes ten cups of snow to make one cup of water."

Snow can provide needed moisture, but realize that it takes ten cups of snow to make one cup of water. Snow can also chill the body, so it is a good idea to melt it first, if at all possible.

☐ **Food.** Food is the next survival requirement. Someone once said that the brain tells us we are hungry, not our stomachs. Most of us can live for quite some time without food, and some of us, obviously, could live much longer than others. The problem is that without food, people get weak, irritable, irrational, and if diabetic, in real trouble. Pack a sandwich, a bag of trail mix, dried or fresh fruit. Hard candy carries some people through extended ventures. Exercise caution when it comes to eating vegetation in the wild. Wild

plants, incorrectly identified, may cause one to become violently ill or worse, die from "natural" causes.

> ## "A signal mirror can also be seen for great distances."

□ **Signaling and Visibility.** Signaling can give searchers an edge. Sound, movement and contrasting colors all make a lost photographer easier to find. Most outdoor photographers attempt to blend in to their surroundings to lessen their impact on nature or to be camouflaged; to aid searchers, the photographer must do just the opposite. Blaze orange cloth-

ing can be seen from an incredible distance. Simple things like a small flashlight, campfire, waving arms or blowing a whistle can also attract the attention of searchers.

A signal mirror can also be seen for great distances. To use it, the pointer finger is held away and up, covering the target. The mirror is held in the other hand, close to the signaler, who moves it until the tip of the finger covering the target lights up from the mirror's reflection. The signal from the mirror should be on course and observed by the target, if they are looking in the right direction.

FINDING YOUR WAY: ORIENTEERING

One of the simplest ways to prevent becoming disoriented is to carry a compass and know how to use it. No one has a sense of

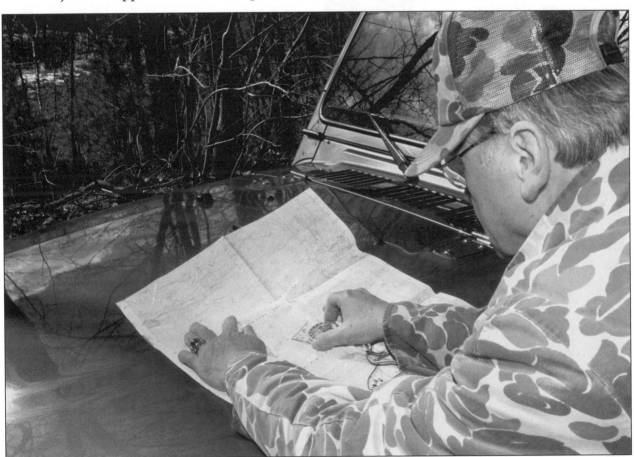

Knowledge of how to use a map and compass will help assure you will not become lost. Topographical maps not only indicate terrain, but elevation as well.

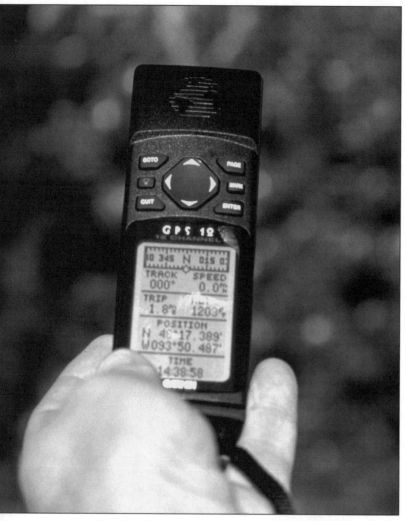

The global positioning system (GPS) indicates longitude and latitude by computing its distance from satellites. Way points can be programmed and stored in a GPS. While the system is easy to use, carry a compass because occasionally a GPS will not acquire satellite contact and batteries can go dead.

wild it is necessary to go around objects, travel downstream or upstream to cross water, etc. Heading east will still provide a return route, but you will probably not end up exactly at the departure point.

"Topographical maps provide the best detail of terrain..."

To return closer to the departure point, make "legs" in the trip. When you have to go off your heading (which was west in this case), mark the area with a sign. Orange surveyor's tape works well, or use an obvious landmark. Make a note of the new heading and when that heading changes, mark it again, make a note of it, and continue to the final point. Then, with reverse headings, find each marker until the starting point is reached. This works in theory, but as with fire building, practice is necessary and should be done under controlled situations. An area map is a nice addition to this procedure. Topographical maps provide the best detail of terrain and are available for most locations.

Other ways to determine direction include pointing the hour hand of a watch at the sun. In the northern hemisphere, halfway between the hour hand and twelve is south. Digital watch? No problem. On the ground, in the snow, or on a piece of paper just draw a watch face with the correct time. Point the hour hand towards the sun and then use the technique.

The pointer stars of the constellation Big Dipper point to Polaris, the North Star. The pointer stars are located on the "bowl" side of the dipper, at the end farthest from the "han-

direction – no one. A compass does not show how to get somewhere or how to return. It simply points to magnetic north (providing it is kept away from metal).

Note the direction you are heading. By adding or subtracting 180 degrees, the heading for the return route can be determined. For example, say you leave your vehicle and head west (270 degrees on the compass). It makes sense that to get back you head east (090 degrees). This is all fine and dandy, except for the fact that when traveling in the

dle." Follow from the top of the dipper about five distances from the bottom to the top of the bowl to find the North Star.

A global positioning system (GPS) is the ultimate direction finder. The new parallel receivers allow GPS technology to be used in areas covered by foliage, etc. Read the instructions before you need the GPS. If you have a GPS, you should still bring a compass. Equipment can fail, can be lost, and batteries can go dead.

> ## "The best survival tool is found between your ears..."

Most of the equipment mentioned here can be purchased from outfitters and camping stores. Carry these items. They are not that bulky, are economical in price and priceless if they're needed. This information isn't remarkable, but is based on common sense. The best survival tool is found between your ears – your brain. Pick up a book on outdoor survival and attend a survival course. You may never need to use these skills, but if you do you will be glad to be familiar with basic survival skills.

SURVIVAL PRIORITIES

- ☐ Have a positive attitude
- ☐ Meet critical medical needs
- ☐ Stay put
- ☐ Find or make shelter
- ☐ Have a safe water source
- ☐ Be able to signal for help
- ☐ Bring or procure food
- ☐ Be able to provide direction finding
- ☐ Again, have a positive attitude

CHAPTER 6

Medical Emergencies – Just in Case

MEDICAL EMERGENCIES

The last thing a photographer needs is a medical emergency. If such an emergency does occur, the first thing the photographer needs is the skill to manage it properly. Since the nature photographer works in locations removed from medical help, he or she must be able to provide necessary medical care, be prepared to summon help and also be able to evacuate the victim for access to a higher level of care.

SCENE SAFETY

In any emergency the first concern is "scene safety." In the wilds, live electrical wires, fast-moving traffic or burning buildings are probably not potential hazards. Instead, establishing "scene safety" might include dealing with overhanging, flimsy tree branches, deep snow, fast-moving or cold water, steep hills or cliffs. Elements in nature that in better circumstances are appreciated for their beauty, take on a sinister presence in an emergency situation.

Potential hazards must be eliminated. A flight instructor once said, "There are old pilots and bold pilots, but there are no old bold pilots." This holds true in an emergency situation as well. It is impossible to provide help to the victim of a medical emergency if you are injured or trapped in the process. The scene must be assessed first and a determination made as to whether immediate care can be provided or if the "big guns" need to be called in. In an emergency situation in a remote area, the choice will be yours.

> "Before a victim... can be cared for, the problem must be defined."

VICTIM ASSESSMENT

Before a victim who is ill or injured can be cared for, the problem must be defined. If you are the victim, you will probably have a good idea of your condition. A victim who is able to talk can often tell what is wrong and what happened. This information gives a complete picture of the situation so that an attempt can be made to provide needed care.

Psychological first aid is often the best first aid. The spoken word can, in some cases, make

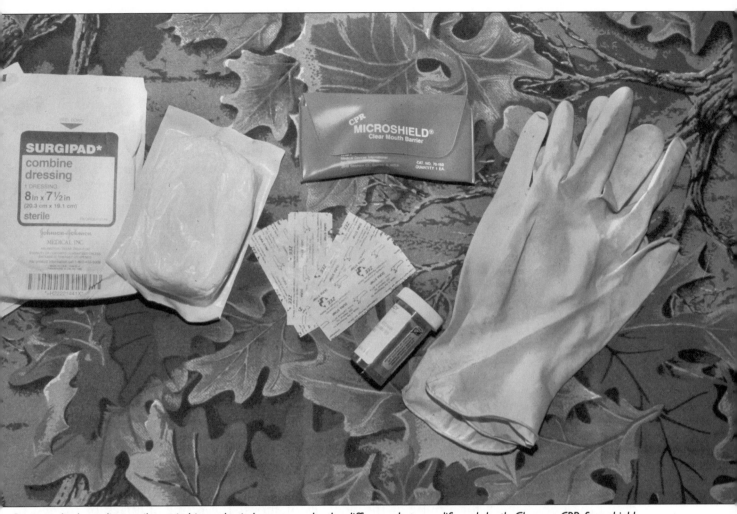

Basic medical supplies, easily carried in a plastic bag, can make the difference between life and death. Gloves, a CPR face shield, dressings and bandages, and personal medications should be carried.

or break a situation. For those who lack experience in handling emergency medical situations, it is often best to speak the truth, but "You're gonna die," is not quite as effective or reassuring as "I'll try to fix you up and get us out of here."

Assessing the victim to pinpoint the problem is easier if the victim can speak. Once the problems are located, they can be addressed. If the victim is not able to speak, a search for the problem will be necessary.

There are two degrees of victim surveys. The first is the primary survey which deals with life-threatening or potentially life-threatening problems. The secondary survey deals with non-life-threatening problems, and is not to be discounted. If overlooked, problems of a secondary nature could be exacerbated by neglect or by movement.

> ## "... problems of a secondary nature could be exacerbated by neglect or by movement."

Basically, a conscious person who is NOT INJURED should be made comfortable. Position the person in the manner he feels best. This may be sitting up, or sometimes lying down. Ask what the problem is and what happened. Often a conscious person may be

short of breath or experiencing chest pain. If he has a medical history, he may be using medication. You can help the person take his medications, if they are available.

If the victim IS INJURED, he or she needs to be kept perfectly still until the problem can be defined. Again, if the victim is conscious, ask what is wrong and what happened. "I tripped and my ankle hurts," gives a pretty good indication of an injured ankle.

"... if the victim is conscious, ask what is wrong and what happened. "

If the injuries are not clearly identified and the history is vague, you will need to use the "hunt and peck" method. Start at the head. Hold it still and determine if the victim is breathing. If he is, continue. If not, start resuscitation rescue breathing. Continue down the body. Check for a pulse at the side of the neck. If there is a pulse, continue with rescue breathing. If there is no pulse, institute cardiopulmonary resuscitation (CPR).

When the victim has been rescued from cold water, a special situation occurs when dealing with cardiopulmonary resuscitation. Under normal circumstances, resuscitation needs to be instituted within six minutes, ten at the most, if a successful recovery is expected. For a cold water victim this time can extend up to an hour. Remarkable rescues and resuscitation outcomes have occurred thanks to the Mammalian Dive Reflex. This reflex moves blood from the arms and legs to the core of the body where it is needed most. The end result is that philosophies have changed regarding resuscitation when dealing

with a cold water near-drowning. Body recoveries are now rescues, and a person is not considered dead until the body is rewarmed and still dead.

Inspect the victim's chest, examining it for any wounds. If there is an air leak, seal it with something air tight. Bruises indicate the possibility that there could be underlying injuries that are potentially dangerous and warrant immediate evacuation.

BLEEDING

Next comes a check for severe bleeding. Severe active external bleeding can be observed by finding the wounds or by seeing a growing puddle of blood on the ground or soaking through clothing. External bleeding is usually easily controlled by simply applying direct pressure to the bleeding site. Clothing may have to be cut away to expose the wound.

SHOCK

Severe internal bleeding is one of the causes of shock, the result of a lack of oxygen to the cells. Death can occur if the cause of shock is not removed, and shock is the final killer of humans. All types of shock can occur anyplace, but there are some particularly significant in the out-of-doors.

Hemorrhagic shock results from blood loss, either external or internal. Blood contains oxygen which is transported to the cells of the body by the circulatory system. Loss of blood results in a lack of oxygen supplied to the cells.

Anaphylactic shock is the result of an allergic reaction. This can be caused by a reaction to insect stings or bites, or from exposure to other irritants such as vegetation. This unique type of shock not only affects the circulatory system, but the respiratory system as well. The allergic reaction can cause the circu-

latory system to enlarge by dilation. Now the "tank" is larger, and even though there is no blood loss, the effect of blood loss is there. In addition, anaphylactic shock can cause the respiratory tract to constrict. Now the victim has trouble getting oxygen into the circulatory system because the oxygen contained in the air does not reach the lungs in an adequate amount.

What do you do for someone who is going into or is already in shock? First, remove the causes. Open the airway. Make sure there is adequate circulation by stopping active bleeding or providing cardiopulmonary resuscitation. Keep the victim still. Provide psychological first aid. Maintain the victim's normal body temperature. Remember that it is often better to provide insulation under a victim than over. Give the victim nothing by mouth to prevent choking and further complications if surgery is required. If injuries allow, raise the lower extremities to facilitate blood flow to the head.

BROKEN BONES

Fractures are broken bones. No one has X-ray vision, so if there is the slightest suspicion that a bone is broken, treat it as such. If there is any suspicion of a joint injury, treat it as a dislocation or fracture. If there is any suspicion of a back or neck injury, treat it as such.

The best care for a fracture is often no care. Think about this: you injure your arm. It hurts to move it. Do you continue to move the arm? Of course not. A person who is conscious and able to do so will place the injured appendage in the most comfortable position, and this is often the best position. If there is a wound related to the fracture, bleeding control might be necessary. Again, use direct pressure.

A suspected fracture needs to be splinted before the victim is moved. Even a person who falls off a gurney in an emergency room has suspected fractures splinted before being moved back onto the cart. Unless an emergency situation (such as in a near drowning or fire) dictates the immediate movement of a victim, splint the victim's injuries where he lays. Use discretion in these situations.

Splints can be "store bought" or fabricated from materials at hand. Whichever is used, attempt to splint the injury in the position in which it was found and extend the splint so it covers the adjacent joints. If moved, joint injuries can cause damage to nerves and vessels. Be careful!

"What do you do for someone who is going into or is already in shock?"

Suspected neck and back injuries are potentially the most dangerous injuries. The spinal cord, which connects the brain to the rest of the body, passes through the spinal column. The spinal cord is about the diameter of a pointer finger and has the consistency of cooked spaghetti. It is fragile! If there is an injury or misplacement of the vertebrae, the spinal cord can be damaged. If severed, nerve connections will be lost from that point downward, resulting in paralysis or death.

Movement after a neck or back injury can be the final blow. Injury to the spinal column may have taken place without damaging the spinal cord. Movement can cause damage to the spinal cord. It is imperative that the victim of a suspected spinal injury not be moved until

professional help arrives, unless there is a real need to do so (risk of fire, drowning, etc.).

This dilemma is one of the most awesome responsibilities placed upon a rescuer. Should the victim be moved or not? Each scenario is different, and in the vast majority of cases the victim will not have to be moved.

ENVIRONMENTAL EMERGENCIES

The human body can tolerate very little change from its normal core temperature of about 99 degrees Fahrenheit. Problems occur with too great a climb in temperature or too much of a drop. Heat exposure can cause heat cramps, heat exhaustion or heat stroke. A drop in the body temperature can lead to hypothermia.

"The human body can tolerate very little change from its normal core temperature..."

■ **Heat-related emergencies.** To avoid heat-related emergencies, avoid excessive exercise in a warm environment and consume adequate fluids. Moisture lost by perspiration contains some salt. Exposure to high temperatures can cause excessive perspiration. Along with the water lost through perspiration, salt also leaves the body. This salt loss can lead to a form of shock and heat cramps (usually abdominal or leg cramps). Salt intake prevents an electrolyte imbalance that can cause weakness, confusion or nausea. Food intake, which usually has salt present, also helps.

The victim of heat exhaustion will appear tired and will have cool, moist skin. In addition to exhaustion, the victim may exhibit signs of confusion. Remove the victim to a cool, shady place if possible, and make him lie down. If the victim is able to swallow, give him or her sips of water. Ideally, the victim should be placed on his or her side, to prevent choking in the case of vomiting. After recovery, the victim can be evacuated.

Heat stroke is the one heat-related condition that is a true emergency. Excessive heat is built up in the body when the heat stroke victim's temperature regulation system shuts down. As a result the victim's body temperature rises to a dangerous level. Loss of consciousness, convulsions and death can result.

First, cool the victim experiencing heat stroke using any method available to accomplish this. If the body temperature is not lowered, the victim will die! Place the victim in cold water if possible. Fashion a cold pack out of any available materials and position it on the body's surface, ideally near areas where larger blood vessels pass close to the surface—the neck, armpits, wrists, ankles and groin area work well for this purpose. Fan the victim. Evacuate the victim or summon help to reach a higher level of medical care as soon as possible.

■ **Cold-related emergencies.** On the other end of the continuum of temperature-related emergencies are cold-related emergencies. As with most situations, avoiding cold-related emergencies is the best approach. Dress adequately and in layers. Exercise enough to allow the body to produce heat, but not enough to cause perspiration.

A drop in the body's temperature causes shivering, an uncontrollable response and nature's way of producing heat. If shivering does not warn the victim to take action like exercising, adding a layer of clothing, seeking shelter or drinking warm liquid, the body temperature will continue to drop. Shivering will

Most areas are close to cellular telephone towers where help can be requested simply by dialing 911. Be prepared to give a location and directions to that location.

stop and body temperature will continue to drop if appropriate action is not taken.

As the body temperature continues to drop, the victim will become drowsy. Next, confusion occurs, signaling the start of the end of the line. At this stage the victim may be unable to care for himself; without helpful intervention, the victim will probably die. No one freezes to death; they become hypothermic, die and then freeze.

Care in the early stage of hypothermia is simple. The victim needs to exercise, get dry if wet, seek shelter, and drink warm liquids. Alcohol should not be consumed because it causes blood vessels to dilate (become larger), increasing the rate at which the body temperature is lowered. Once the victim is rewarmed, normal activities can probably be resumed.

In a life-or-death hypothermia situation, modesty is at the bottom of the list of priori-

ties. The victim can be placed naked in blankets or a sleeping bag. The rescuer, also naked, can then occupy the same blankets or sleeping bag. Heat will be transferred from the rescuer to the victim. You can practice this procedure before the emergency occurs, if you so desire.

If hypothermia is severe and the victim is unconscious or not breathing, prevent further heat loss and avoid rough handling. Improper treatment can cause the heart to go into ventricular fibrillation. Institute CPR, if indicated, and evacuate the victim. Remember, no one cold is dead.

CALLING FOR HELP

When an emergency occurs in a remote location, conditions may prevent travel out of the area. In this case it is necessary to summon help. Cellular telephones are a logical solution to calling for help and, in most areas of the country, cell phones are capable of reaching a cellular tower. In most areas, dialing 911 will reach an emergency dispatcher who can summon the appropriate support services to your location. Another less common means of summoning help is the two-way radio. No matter what technology is utilized, fresh batteries are essential.

Again, prevention is the key to safety. Inform someone of your timetable and plans before a photo outing and help may come to you if the timetable is not met. Before entering a remote location, know how to contact emergency services in that area. When calling for help, be prepared to give the location and directions to the scene of the emergency. Remember to give your cell phone number to the dispatcher in case additional information or directions are needed.

A situation may arise where help must be summoned, but the location of an emergency prevents it. In this case the option is to leave the scene (and the victim) to get help. If the victim must be left behind, attempt to provide shelter. If the victim is unconscious, breathing and uninjured, place him or her in the recovery position (on the side), to maintain an open airway.

> ## "... a method of evacuation may need to be improvised."

Once the victim is cared for to the extent possible at the scene, evacuation must be considered. First think, "Is there a need to evacuate? Is there a need to evacuate now, or can it wait?" If evacuation can be postponed, let it. This will allow time to summon help. Hopefully, professionals can be summoned, but in extreme cases, when help is not available, a method of evacuation may need to be improvised. If his or her injuries or condition allows, the victim may be able to help with the evacuation process. If the victim is unable to help, use the resources available or go for help.

TRAINING

The importance of completing a first aid and cardiopulmonary resuscitation course cannot be stressed enough. Skills learned in the courses can make an emergency situation manageable, and perhaps prevent a tragedy. To enroll in an emergency medical care course, contact your local hospital or ambulance service provider for information.

Emergency medical training not only provides good basic first aid knowledge, but prepares the student to deal with emergencies in general.

Suggested Reading

BOOKS:

Burian, Peter and Captuo, Robert. *Photography Field Guide*. (National Geographic Society, 1999).

Caulfied, Patricia. *Photographing Wildlife*. (Amphoto, New York, NY, 1988).

Collett, John and Collett, David. *Black & White Landscape Photography*. (Amherst Media, Inc., Buffalo, NY, 1999).

Gallagher, Tim. *Wild Bird Photography*. (Lyons & Burford, New York, NY, 1994).

Golden Guides and Golden Field Guides. (Western Publishing Co. Inc., Racine, WI).

Kahn, Cub. *Essential Skills for Nature Photographers*. (Amherst Media, Inc., Buffalo, NY, 1999).

McDonald, Joe. *Wildlife Photographer's Field Manual*. (Amherst Media, Inc., Buffalo, NY, 1999).

National Audubon Society Field Guide to North American Birds— Eastern Region and Western Region. (Alfred A. Knopf, Inc., NY, 1994, 1995).

Reader's Digest North American Wildlife Reader's Digest Association. (Pleasantville, NY 1982).

Roger Tory Peterson Field Guides. (Houghton Mifflin Company, Boston, MA).

Shaw, John. *Focus on Nature*. (Amphoto, New York, NY 1991).

Shaw, John. *The Nature Photographer's Complete Guide to Professional Field Techniques.* (Amphoto, New York, NY 1984).

West, Larry & Ridl, Julie. *How to Photograph Birds.* (Stackpole Books, Ottawa, 1993).

PERIODICALS:

Outdoor Photographer. (Werner Publishing Corp.)

Petersen's Photography. (Petersen Publishing Company)

Popular Photography. (Hachette Filipacchi Magazines, Inc.)

CD ROMS:

Birds of North America. (Thayer Birding Software, Cincinnati, OH, 1997).

North American Birds. (Houghton Mifflin Interactive, Somerville, MA, 1995).

National Audubon Society Interactive CD-ROM Guide to North American Birds. (Alfred A. Knopf, Inc., NY 1996).

INTERNET RESOURCES:

A quick search for "Nature Photography" on any major search engine will yield hundreds of results. Don't forget also to search for special areas which interest you – bird photography, landscape photography, tracking animals, etc. The sites listed below will provide a good starting point for basic research on the internet. Each site also provides links to more specialized sub-topics.

www.naturepix.com/
Features books, magazines, tour information and contact information for national organizations of interest to nature photographers.

www.nanpa.org/
The official site of the North American Nature Photography Association. Contains information designed to promote education, professional behavior and environmental protection.

www.nwf.org/
Web site of the National Wildlife Federation.

Resource for environmental education, conservation and outdoor adventures.

www.photnet/nature/photo

Offers a nature photography discussion forum, guides and reference articles, field ethics and equipment reviews.

nps.gov/refdesk/

Web site of the National Parks Service. Covers basic information on the parks, contact information, park maps and fees. For still photography guidelines, visit <http://nps/gov/htdocs3/refdesk/DOrders/a20x1.html>.

SUPPLIERS:

B & H
420 9th Ave.
New York City, NY 10001
1-800-947-6628

Should be able to fill all photo needs.

Bogen Photo Corp.
565 E. Crescent Avenue
P.O. Box 506
Ramsey, NJ 07446-0506
201-818-9500

Fine tripods, heads and accessories.

BPS Marketing, Inc.
18642 142nd Ave. NE
Woodinville, WA 98072-8521
425-486-6166

Their Ultra-Pod mini-tripods and window mounts are excellent.

Cabelas
One Cabela Drive
Sidney, NE 69160
1-800-237-4444

For outdoor equipment—you name it, they have it.

Campmor
P.O. Box 700-Q
Saddle River, NJ 07458-0700
1-800-CAMPMOR
Lots of outdoor gear.

Duluth Tent & Awning, Inc.
P.O. Box 16024
Duluth, MN 55816
1-800-777-4439
You'd swear their packs are bulletproof, even though they aren't.

Garmin International
1200 East 151st Street
Olathe, KS 66062
913-397-8200
Manufacturer of quality global positioning systems.

Ocean Instruments
5312 Banks Street
San Diego, CA 92110
619-291-2557
They manufacture a wonderful rifle-type camera mount.

Peca Products, Inc.
1441 Plainfield Avenue
Janesville, WI 53545-0299
608-756-1615
Accessory products for the photo and optical industry including soft camera supports.

Peli Products
23215 Early Avenue
Torrence, CA 90505
310-326-4700
Makers of the world's toughest, unbreakable, waterproof, dustproof equipment cases.

Steger Mukluks
 100 Miners Drive
 Ely, MN 55731
 1-800-MUK-LUKS
The warmest and lightest boots you'll ever find!

The Vested Interest
 1425 Century Lane, Suite 100
 Carrollton, TX 75006
 972-245-4256
 FAX 972-245-0598
Photo gear preferred by professionals—makers of the Xtrahand vest, the most durable and functional photo vest available.

ABOUT THE AUTHORS:

Ralph LaPlant is employed as a Tribal Conservation Officer for the Mille Lacs Band of Ojibwe, and is an outdoor and canoeing enthusiast. As a paramedic for over twenty years, he has authored and taught courses on emergency medicine and outdoor survival. He has also been an avid photographer for over thirty years. His photography and writing venture, North Woods Images, is based out of his home in Garrison, MN. He has photographed and written for numerous local, regional and national publications, and writes a nature-related newspaper column.

Amy Sharpe is a freelance artist and writer, as well as the managing editor of a weekly newspaper. She has worked as a journalist for the past 25 years. Since 1992, she has been the editor/publisher of *Homespun* magazine, a regional arts-oriented publication. As a naturalist, she has taught outdoor education, forest ecology and outdoor living skills. She resides in Bay Lake, MN.

Index

Other Books from
Amherst Media, Inc.

Basic 35mm Photo Guide

Craig Alesse

Great for beginning photographers! Designed to teach 35mm basics step-by-step — completely illustrated. Features the latest cameras. Includes: 35mm automatic, semi-automatic cameras, camera handling, *f*-stops, shutter speeds, and more! $12.95 list, 9x8, 112p, 178 photos, order no. 1051.

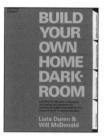

Build Your Own Home Darkroom

Lista Duren & Will McDonald

This classic book teaches you how to build a high quality, inexpensive darkroom in your basement, spare room, or almost anywhere. Includes valuable information on: darkroom design, woodworking, tools, and more! $17.95 list, 8½x11, 160p, order no. 1092.

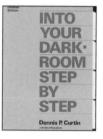

Into Your Darkroom Step-by-Step

Dennis P. Curtin

This is the ideal beginning darkroom guide. Easy to follow and fully illustrated each step of the way. Includes information on: the equipment you'll need, set-up, making proof sheets and much more! $17.95 list, 8½x11, 90p, hundreds of photos, order no. 1093.

Wedding Photographer's Handbook

Robert and Sheila Hurth

A complete step-by-step guide to succeeding in the world of wedding photography. Packed with shooting tips, equipment lists, must-get photo lists, business strategies, and much more! $24.95 list, 8½x11, 176p, index, b&w and color photos, diagrams, order no. 1485.

Lighting for People Photography

Stephen Crain

The complete guide to lighting. Includes: set-ups, equipment information, strobe and natural lighting, and much more! Features diagrams, illustrations, and exercises for practicing the techniques discussed in each chapter. $29.95 list, 8½x11, 112p, b&w and color photos, glossary, index, order no. 1296.

Camera Maintenance & Repair Book 1

Thomas Tomosy

A step-by-step, illustrated guide by a master camera repair technician. Includes: testing camera functions, general maintenance, basic tools needed and where to get them, basic repairs for accessories, camera electronics, plus "quick tips" for maintenance and more! $29.95 list, 8½x11, 176p, order no. 1158.

Camera Maintenance & Repair Book 2

Thomas Tomosy

Build on the basics covered Book 1, with advanced techniques. Includes: mechanical and electronic SLRs, zoom lenses, medium format cameras, and more. Features models not included in the Book 1. $29.95 list, 8½x11, 176p, 150+ photos, charts, tables, appendices, index, glossary, order no. 1558.

Restoring the Great Collectible Cameras (1945-70)

Thomas Tomosy

More step-by-step instruction on how to repair collectible cameras. Covers postwar models (1945-70). Hundreds of illustrations show disassembly and repair. $29.95 list, 8½x11, 128p, 200+ photos, index, order no. 1560.

Big Bucks Selling Your Photography

Cliff Hollenbeck

A complete photo business package. Includes secrets for starting up, getting paid the right price, and creating successful portfolios! Features setting financial, marketing and creative goals. Organize your business planning, bookkeeping, and taxes. $15.95 list, 6x9, 336p, order no. 1177.

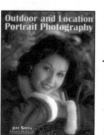

Outdoor and Location Portrait Photography

Jeff Smith

Learn how to work with natural light, select locations, and make clients look their best. Step-by-step discussions and helpful illustrations teach you the techniques you need to shoot outdoor portraits like a pro! $29.95 list, 8½x11, 128p, b&w and color photos, index, order no. 1632.

Make Money with Your Camera

David Arndt

Learn everything you need to know in order to make money in photography! David Arndt shows how to take highly marketable pictures, then promote, price and sell them. Includes all major fields of photography. $29.95 list, 8½x11, 120p, 100 b&w photos, index, order no. 1639.

Professional Secrets of Advertising Photography

Paul Markow

No-nonsense information for those interested in the business of advertising photography. Includes: how to catch the attention of art directors, make the best bid, and produce the high-quality images your clients demand. $29.95 list, 8½x11, 128p, 80 photos, index, order no. 1638.

Leica Camera Repair Handbook

Thomas Tomosy

A detailed technical manual for repairing Leica cameras. Each model is discussed individually with step-by-step instructions. Exhaustive photographic illustration ensures that every step of the process is easy to follow. $39.95 list, 8½x11, 128p, 130 b&w photos, appendix, order no. 1641.

Lighting Techniques for Photographers

Norm Kerr

This book teaches you to predict the effects of light in the final image. It covers the interplay of light qualities, as well as color compensation and manipulation of light and shadow. $29.95 list, 8½x11, 120p, 150+ color and b&w photos, index, order no. 1564.

Guide to International Photographic Competitions

Dr. Charles Benton

Remove the mystery from international competitions with all the information you need to select competitions, enter your work, and use your results for continued improvement and further success! $29.95 list, 8½x11, 120p, b&w photos, index, appendices, order no. 1642.

Infrared Photography Handbook

Laurie White

Covers black and white infrared photography: focus, lenses, film loading, film speed rating, batch testing, paper stocks, and filters. Black & white photos illustrate how IR film reacts. $29.95 list, 8½x11, 104p, 50 b&w photos, charts & diagrams, order no. 1419.

Freelance Photographer's Handbook

Cliff & Nancy Hollenbeck

Whether you want to be a freelance photographer or are looking for tips to improve your current freelance business, this volume is packed with ideas for creating and maintaining a successful freelance business. $29.95 list, 8½x11, 107p, 100 b&w and color photos, index, glossary, order no. 1633.

How to Shoot and Sell Sports Photography

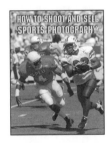

David Arndt

A step-by-step guide for amateur photographers, photojournalism students and journalists seeking to develop the skills and knowledge necessary for success in the demanding field of sports photography. $29.95 list, 8½x11, 120p, 111 photos, index, order no. 1631.

Infrared Landscape Photography

Todd Damiano

Landscapes shot with infrared can become breathtaking and ghostly images. The author analyzes over fifty of his most compelling photographs to teach you the techniques you need to capture landscapes with infrared. $29.95 list, 8½x11, 120p, b&w photos, index, order no. 1636.

How to Operate a Successful Photo Portrait Studio

John Giolas

Combines photographic techniques with practical business information to create a complete guide book for anyone interested in developing a portrait photography business (or improving an existing business). $29.95 list, 8½x11, 120p, 120 photos, index, order no. 1579.

Wedding Photography:
Creative Techniques for Lighting and Posing

Rick Ferro

Creative techniques for lighting and posing wedding portraits that will set your work apart from the competition. Covers every phase of wedding photography. $29.95 list, 8½x11, 128p, b&w and color photos, index, order no. 1649.

Fashion Model Photography

Billy Pegram

For the photographer interested in shooting commercial model assignments, or working with models to create portfolios. Includes techniques for dramatic composition, posing, selection of clothing, and more! $29.95 list, 8½x11, 120p, 58 photos, index, order no. 1640.

Computer Photography Handbook

Rob Sheppard

Learn to make the most of your photographs using computer technology! From creating images with digital cameras, to scanning prints and negatives, to manipulating images, you'll learn all the basics of digital imaging. $29.95 list, 8½x11, 128p, 150+ photos, index, order no. 1560.

Professional Secrets for Photographing Children

Douglas Allen Box

Covers every aspect of photographing children on location and in the studio. Prepare children and parents for the shoot, select the right clothes capture a child's personality, and shoot story book themes. $29.95 list, 8½x11, 128p, 74 photos, index, order no. 1635.

Achieving the Ultimate Image

Ernst Wildi

Ernst Wildi teaches the techniques required to take world class, technically flawless photos. Features: exposure, metering, the Zone System, composition, evaluating an image, and more! $29.95 list, 8½x11, 128p, 120 b&w and color photos, index, order no. 1628.

Telephoto Lens Photography

Rob Sheppard

A complete guide for telephoto lenses. Shows you how to take great wildlife photos, portraits, sports and action shots, travel pics, and much more! Features over 100 photographic examples. $17.95 list, 8½x11, 112p, b&w and color photos, index, glossary, appendices, order no. 1606.

Black & White Portrait Photography

Helen Boursier

Make money with b&w portrait photography. Learn from top b&w shooters! Studio and location techniques, with tips on preparing your subjects, selecting settings and wardrobe, lab techniques, and more! $29.95 list, 8½x11, 128p, 130+ photos, index, order no. 1626

Restoring Classic & Collectible Cameras (Pre-1945)

Thomas Tomosy

Step-by-step instructions show how to restore a classic or vintage camera. Repair mechanical and cosmetic elements to restore your valuable collectibles. $34.95 list, 8½x11, 128p, b&w photos and illus., glossary, index, order no. 1613.

The Beginner's Guide to Pinhole Photography

Jim Shull

Take pictures with a camera you make from stuff you have around the house. Develop and print the results at home! Pinhole photography is fun, inexpensive, educational and challenging. $17.95 list, 8½x11, 80p, 55 photos, charts & diagrams, order no. 1578.

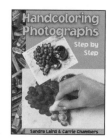

Handcoloring Photographs Step-by-Step

Sandra Laird & Carey Chambers

Learn to handcolor photographs step-by-step with the new standard in handcoloring reference books. Covers a variety of coloring media and techniques with plenty of colorful photographic examples. $29.95 list, 8½x11, 112p, 100+ color and b&w photos, order no. 1543.

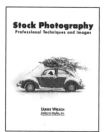

Stock Photography

Ulrike Welsh

This book provides an inside look at the business of stock photography. Explore photographic techniques and business methods that will lead to success shooting stock photos — creating both excellent images and business opportunities. $29.95 list, 8½x11, 120p, 58 photos, index, order no. 1634.

Special Effects Photography Handbook

Elinor Stecker Orel

Create magic on film with special effects! Little or no additional equipment required, use things you probably have around the house. Step-by-step instructions guide you through each effect. $29.95 list, 8½x11, 112p, 80+ color and b&w photos, index, glossary, order no. 1614.

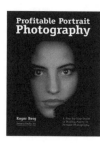

Profitable Portrait Photography

Roger Berg

A step-by-step guide to making money in portrait photography. Combines information on portrait photography with detailed business plans to form a comprehensive manual for starting or improving your business. $29.95 list, 8½x11, 104p, 100 photos, index, order no. 1570

McBroom's Camera Bluebook

Mike McBroom

Comprehensive and fully illustrated, with price information on: 35mm, medium & large format cameras, exposure meters, strobes and accessories. Pricing info based on equipment condition. A must for any camera buyer, dealer, or collector! $29.95 list, 8½x11, 224p, 75+ photos, order no. 1263.

Fine Art Portrait Photography

Oscar Lozoya

The author examines a selection of his best photographs, and provides detailed technical information about how he created each. Lighting diagrams accompany each photograph. $29.95 list, 8½x11, 128p, 58 photos, index, order no. 1630.

Family Portrait Photography

Helen Boursier

Learn from professionals how to operate a successful portrait studio. Includes: marketing family portraits, advertising, working with clients, posing, lighting, and selection of equipment. Includes images from a variety of top portrait shooters. $29.95 list, 8½x11, 120p, 123 photos, index, order no. 1629.

The Art of Infrared Photography, *4th Edition*

Joe Paduano

A practical guide to the art of infrared photography. Tells what to expect and how to control results. Includes: anticipating effects, color infrared, digital infrared, using filters, focusing, developing, printing, handcoloring, toning, and more! $29.95 list, 8½x11, 112p, order no. 1052

Camcorder Tricks and Special Effects, *revised*

Michael Stavros

Kids and adults can create home videos and mini-masterpieces that audiences will love! Use materials from around the house to simulate an inferno, make subjects transform, create exotic locations, and more. Works with any camcorder. $17.95 list, 8½x11, 80p, order no. 1482.

The Art of Portrait Photography

Michael Grecco

Michael Grecco reveals the secrets behind his dramatic portraits which have appeared in magazines such as *Rolling Stone* and *Entertainment Weekly*. Includes: lighting, posing, creative development, and more! $29.95 list, 8½x11, 128p, order no. 1651.

Essential Skills for Nature Photography

Cub Kahn

Learn all the skills you need to capture landscapes, animals, flowers and the entire natural world on film. Includes: selecting equipment, choosing locations, evaluating compositions, filters, and much more! $29.95 list, 8½x11, 128p, order no. 1652.

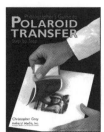

Photographer's Guide to Polaroid Transfer

Christopher Grey

Step-by-step instructions make it easy to master Polaroid transfer and emulsion lift-off techniques and add new dimensions to your photographic imaging. Fully illustrated every step of the way to ensure good results the very first time! $29.95 list, 8½x11, 128p, order no. 1653.

Black & White Landscape Photography

John Collett and David Collett

Master the art of b&w landscape photography. Includes: selecting equipment (cameras, lenses, filters, etc.) for landscape photography, shooting in the field, using the Zone System, and printing your images for professional results. $29.95 list, 8½x11, 128p, order no. 1654.

Wedding Photojournalism

Andy Marcus

Learn the art of creating dramatic unposed wedding portraits. Working through the wedding from start to finish you'll learn where to be, what to look for and how to capture it on film. A hot technique for contemporary wedding albums! $29.95 list, 8½x11, 128p, order no. 1656.

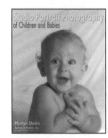

Studio Portrait Photography of Children and Babies

Marilyn Sholin

Learn to work with the youngest portrait clients to create images that will be treasured for years to come. Includes tips for working with kids at every developmental stage, from infant to pre-schooler. Features: lighting, posing and much more! $29.95 list, 8½x11, 128p, order no. 1657.

Professional Secrets of Wedding Photography

Douglas Allen Box

Over fifty top-quality portraits are individually analyzed to teach you the art of professional wedding portraiture. Lighting diagrams, posing information and technical specs are included for every image. $29.95 list, 8½x11, 128p, order no. 1658.

Photographer's Guide to Shooting Model & Actor Portfolios

CJ Elfont, Edna Elfont and Alan Lowy

Learn to create outstanding images for actors and models looking for work in fashion, theater, television, or the big screen. Includes the business, photographic and professional information you need to succeed! $29.95 list, 8½x11, 128p, order no. 1659.

Photo Retouching with Adobe Photoshop

Gwen Lute

Designed for photographers, this manual teaches every phase of the process, from scanning to final output. Learn to restore damaged photos, correct imperfections, create realistic composite images and correct for dazzling color. $29.95 list, 8½x11, 128p, order no. 1660.

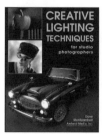

Creative Lighting Techniques for Studio Photographers

Dave Montizambert

Master studio lighting and gain complete creative control over your images. Whether you are shooting portraits, cars, table-top or any other subject, Dave Montizambert teaches you the skills you need to confidently create with light. $29.95 list, 8½x11, 128p, order no. 1666.

Storybook Wedding Photography

Barbara Box

Barbara and her husband shoot as a team at weddings. Here, she shows you how to create outstanding candids (which are her specialty), and combine them with formal portraits (her husband's specialty) to create a unique wedding album. $29.95 list, 8½x11, 128p, order no. 1667.

Fine Art Children's Photography

Doris Carol Doyle

Learn to create fine art portraits of children in black & white. Included is information on: posing, lighting for studio portraits, shooting on location, clothing selection, working with kids and parents, and much more! $29.95 list, 8½x11, 128p, order no. 1668.

Infrared Portrait Photography

Richard Beitzel

Discover the unique beauty of infrared portraits, and learn to create them yourself. Included is information on: shooting with infrared, selecting subjects and settings, filtration, lighting, and much more! $29.95 list, 8½x11, 128p, order no. 1669.

Black & White Photography for 35mm

Richard Mizdal

A guide to shooting and darkroom techniques! Perfect for beginning or intermediate photographers who wants to improve their skills. Features helpful illustrations and exercises to make every concept clear and easy to follow. $29.95 list, 8½x11, 128p, order no. 1670.

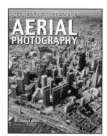

Secrets of Successful Aerial Photography

Richard Eller

Learn how to plan for every aspect of a shoot and take the best possible images from the air. Discover how to control camera movement, compensate for environmental conditions and compose outstanding aerial images. $29.95 list, 8½x11, 120p, order no. 1679.

Professional Secrets of Nature Photography

Judy Holmes

Learn how to prove your nature photography right away with the techniques in this must-have book. Covers every aspect of making top-quality images, from selecting the right equipment, to choosing the best subjects, to shooting techniques for professional results every time. $29.95 list, 8½x11, 120p, order no. 1682.

Macro and Close-up Photography Handbook

Stan Sholik

Leanr to get close and capture breathtaking images of small subjects – flowers, stamps, jewellry, insects, etc. Designed with the 35mm shooter in mind, this is a comprehensive manual full of step-by-step techniques. $29.95 list, 8½x11, 120p, order no. 1686.

AMHERST MEDIA'S CUSTOMER REGISTRATION FORM

Please fill out this sheet and send or fax to receive free information about future publications from Amherst Media.

CUSTOMER INFORMATION

DATE

NAME

STREET OR BOX #

CITY STATE

ZIP CODE

PHONE ()

OPTIONAL INFORMATION

I **BOUGHT** *Outdoor and Survival Skills for Nature Photographers* **BECAUSE**

I FOUND THESE CHAPTERS TO BE MOST USEFUL

I PURCHASED THE BOOK FROM

City State

I WOULD LIKE TO SEE MORE BOOKS ABOUT

I PURCHASE ___ BOOKS PER YEAR

ADDITIONAL COMMENTS

FAX to: 1-800-622-3298

Name_____
Address_____
City_____State____
Zip_____ — _____

**Amherst Media, Inc.
PO Box 586
Amherst, NY 14226**